REMEMBERING QUEENS

Kevin Sean O'Donoghue

TURNER

PUBLISHING COMPANY

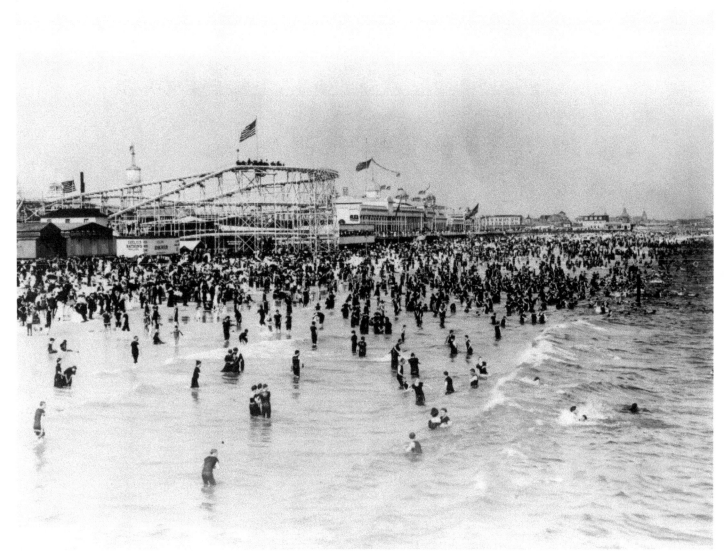

Along with Wainwright & Smith's pavilions, Playland once provided popular entertainment for the citizens of Queens. Here in 1906, throngs congregate on the beach with the amusement park and its roller coaster in the background.

REMEMBERING
QUEENS

Turner Publishing Company
www.turnerpublishing.com

Remembering Queens

Library of Congress Control Number: 2011929753

ISBN: 9781596528345

Printed in the United States of America

ISBN: 978-1-68336-875-5 (pbk.)

CONTENTS

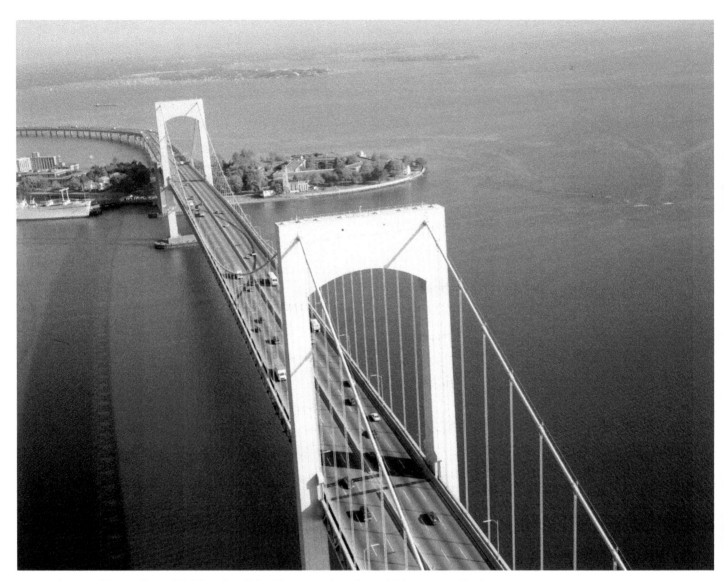

An aerial view of Queens' own "Golden Gate," the Throgs Neck Bridge, which connects the Bronx to Bayside. This view, looking south, shows Little Neck Bay with Queens stretched out in the mist in the far distance. Completed in 1961, the bridge is nearly 3,000 feet long and was designed by Othmann Amman, who was also responsible for the George Washington, Triborough, and Verrazano-Narrows suspension bridges. The Throgs Neck was built to relieve traffic build-up at the nearby Whitestone Bridge.

ACKNOWLEDGMENTS

This volume, *Remembering Queens,* is the result of the cooperation and efforts of many individuals and organizations. It is with great thanks that we acknowledge the valuable contribution of the following for their generous support:

The Library of Congress
The New York State Library
The Queensboro Public Library

I would also like to thank my wife, professor Kate O'Donoghue, who patiently proofread all of my work and let me wake up late on Saturdays after I worked on the book.

PREFACE

Thousands of historic photographs of the borough of Queens reside in archives, both local and national. This book began with the observation that, while these photographs are of great interest to many, they are not easily accessible. During a time when Queens is looking ahead and evaluating its future course, many people are asking, How do we treat the past? These decisions affect every aspect of the city—architecture, public spaces, commerce, infrastructure—and these, in turn, affect the way that people live their lives. This book seeks to provide easy access to a valuable, objective look into the history of Queens.

The power of photographs is that they are less subjective than words in their treatment of history. Although the photographer can make subjective decisions regarding subject matter and how to capture and present it, photographs seldom interpret the past to the extent textual histories can. For this reason, photography is uniquely positioned to offer an original, untainted look at the past, allowing the viewer to learn for himself what the world was like a century or more ago.

This project represents countless hours of review and research. The researchers and writer have reviewed thousands of photographs in numerous archives. We greatly appreciate the generous assistance of the individuals and organizations listed in the acknowledgments of this work, without whom this project could not have been completed.

The goal in publishing this work is to provide broader access to this set of extraordinary photographs that seek to inspire, provide perspective, and evoke insight that might assist people who are responsible for determining the future of Queens. In addition, the book seeks to preserve the past with adequate respect and reverence.

With the exception of touching up imperfections that have accrued with the passage of time and cropping where necessary, no changes have been made. The focus and clarity of many images are limited to the technology and the ability of the photographer at the time they were recorded.

The work is divided into eras. Beginning with some of the earliest known photographs of Queens, the first section takes a look at the closing decades of the nineteenth century. The second section spans the metamorphosis of Queens from a rural to an urban borough, from the beginning of the twentieth century to the eve of the Great Depression. Section Three focuses on the 1930s. The last section covers the World War II and postwar eras to recent times. In each of these sections we have made an effort to capture various aspects of life through our selection of photographs. People, commerce, transportation, infrastructure, religious institutions, and educational institutions have been included to provide a broad perspective.

We encourage the citizens of and visitors to Queens to think about the city as they stroll its parks and move about its neighborhoods. It is the publisher's hope that in utilizing this work, longtime residents will learn something new and that new residents will gain a perspective on where Queens has been, so that each can contribute to its future.

—*Todd Bottorff, Publisher*

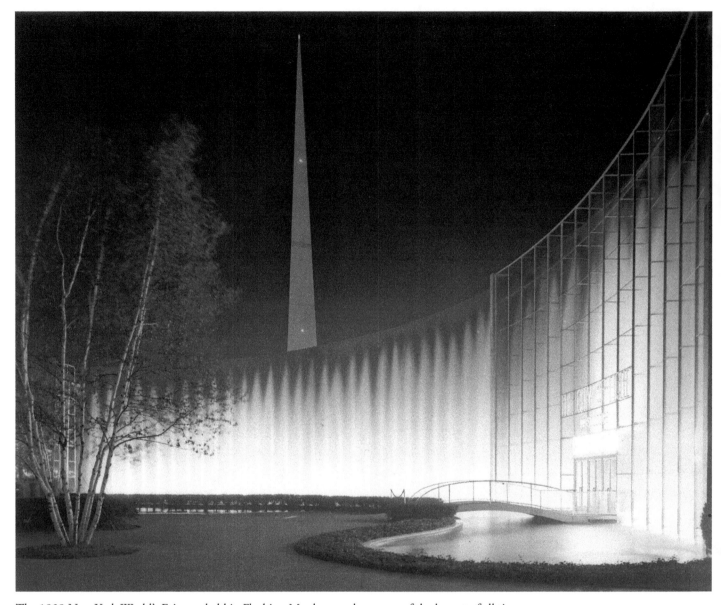

The 1939 New York World's Fair was held in Flushing Meadows and was one of the largest of all time. Shown here are the Consolidated Edison lighted fountains and the 700-foot-tall Trylon. New York would host another world's fair on the same site in 1964.

A Shrinking County, a Growing Borough

(1880s–1899)

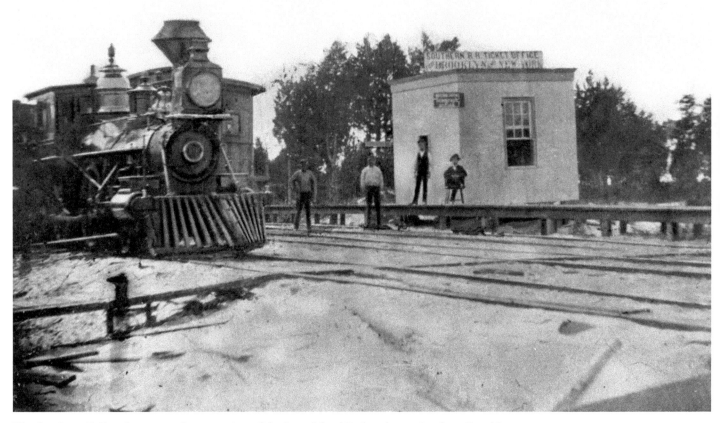

The Southern Railroad was an early competitor of the Long Island Railroad, running from Brooklyn to Montauk on part of what is now the LIRR's Main Line. The LIRR eventually assumed control of the Southern's lines, including this one in Far Rockaway, which brought early city dwellers to the Atlantic beaches.

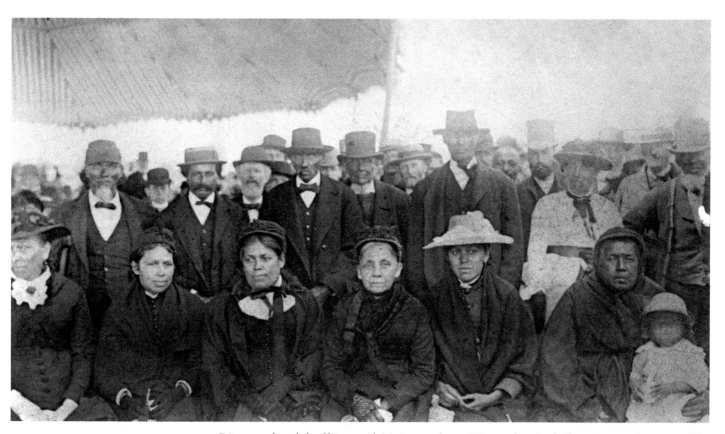

Disease reduced the Shinnecock Nation to about 200 members in the late nineteenth century. The tribe has faced multiple "extinction" rumors as demonstrated by the title "Last of the Shinnecock Indians" on this photograph taken in Flushing in 1884. However, the tribe continues to have a presence on eastern Long Island, including a reservation where 600 people reside, adjacent to the town of Southampton.

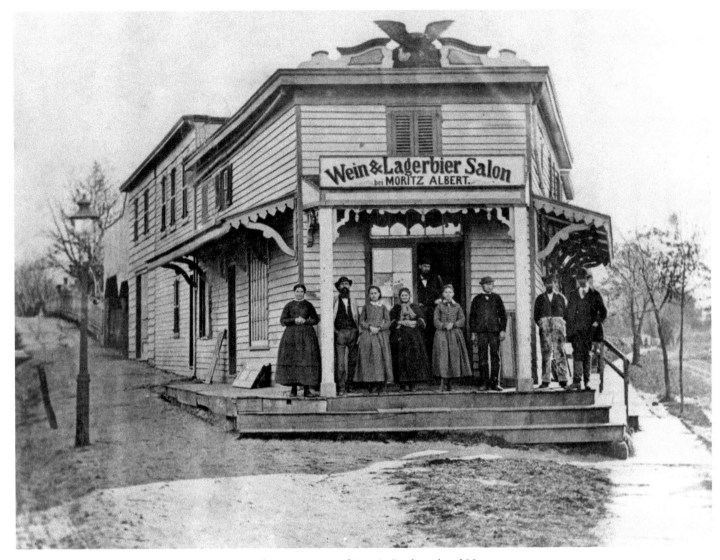

This photograph shows Albert Moritz's tavern at the intersection of Astoria Boulevard and Newtown Road, located in what had been the Village of Astoria. The village joined the newly incorporated Long Island City when it split from the town of Newton, one of the original towns composing Queens County.

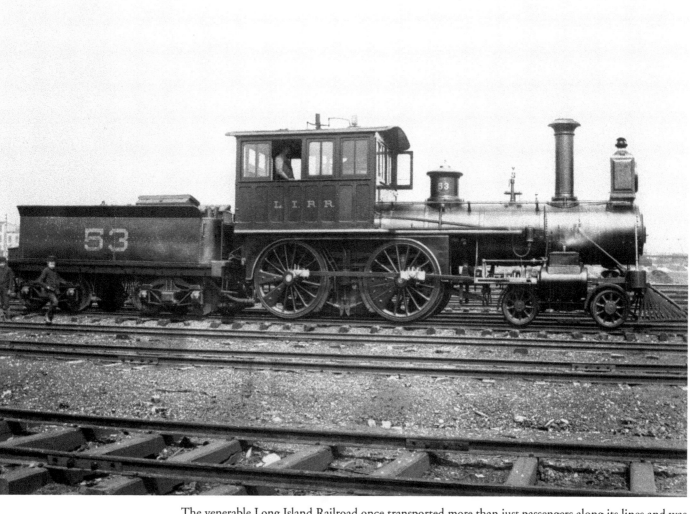

The venerable Long Island Railroad once transported more than just passengers along its lines and was a conduit both into and out of New York City. Its lines crossed the full length of Queens, which at the time stretched deep into what is now Suffolk County. Here the 4-4-0 Engine No. 53 is seen pulling freight through the Long Island City yards.

This mill, identified as "Wilson's Mill," stood in what would have been the Village of Astoria. At the time, Astoria was a recreational area for wealthy citizens, who built large vacation homes in the countryside just across the river from Manhattan.

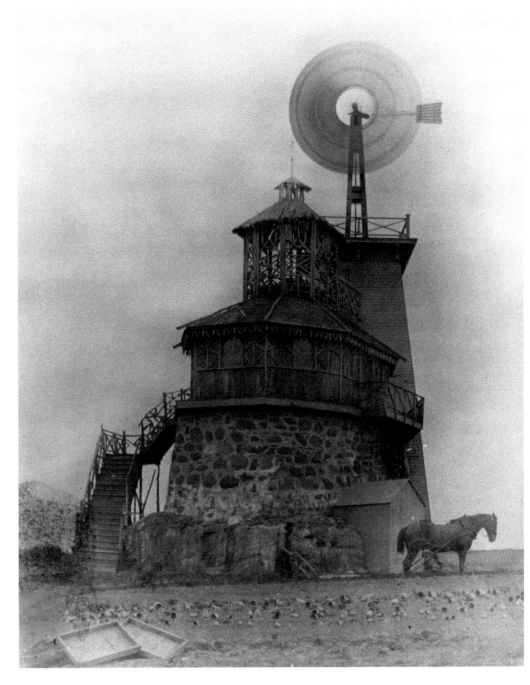

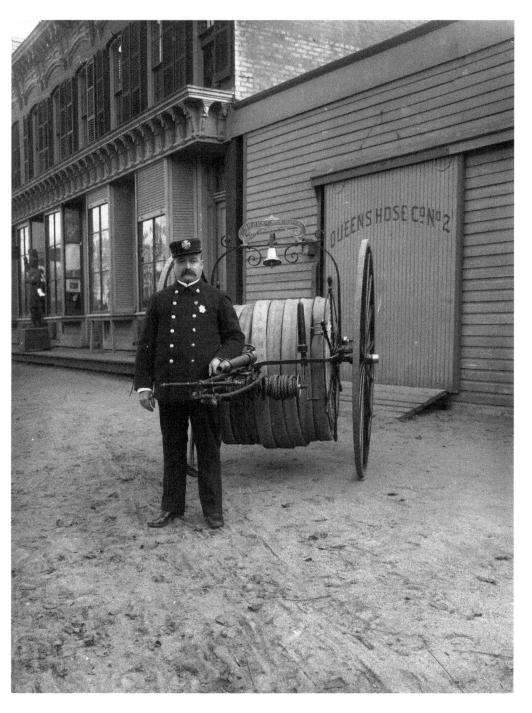

This fire fighter is identified as George Barb, of Queens Hose Company No. 2, located in Queens Village on the eastern side of the town of Jamaica. Mr. Barb is shown with a hand-drawn "hose cart"—cutting-edge fire-fighting technology at the time. Fire companies were proud of their organizations and frequently competed in parades and other public demonstrations.

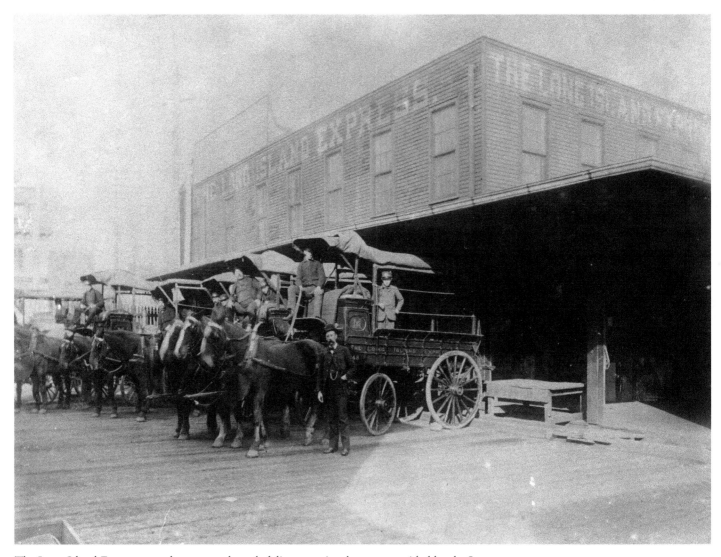

The Long Island Express was a baggage and trunk delivery service that was provided by the Long Island Railroad to its customers. Here a company of drivers pose atop their horse-drawn "trucks" outside the Express building in Long Island City.

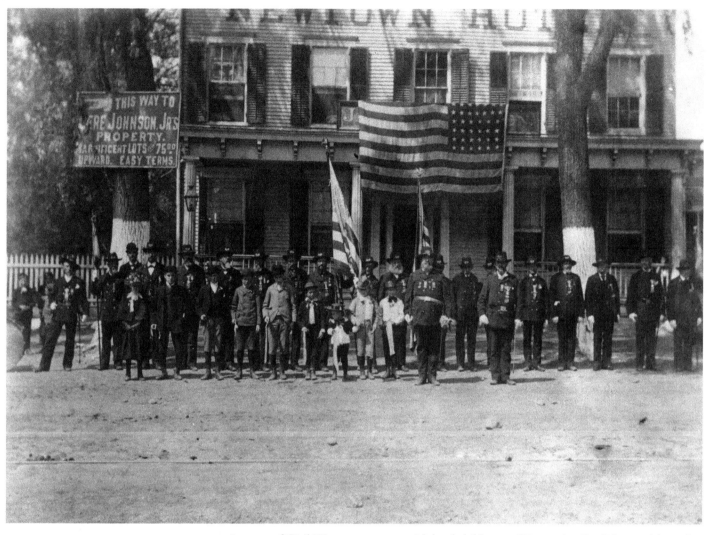

A group of Civil War veterans pose with local children on "Decoration Day" (now celebrated as Memorial Day) in front of the Newtown Hotel at the intersection of Broadway and Maurice Avenue on May 30, 1891, with the Stars and Stripes oddly displayed in reverse. The veterans are likely from the Robert Marks Post, Grand Army of the Republic.

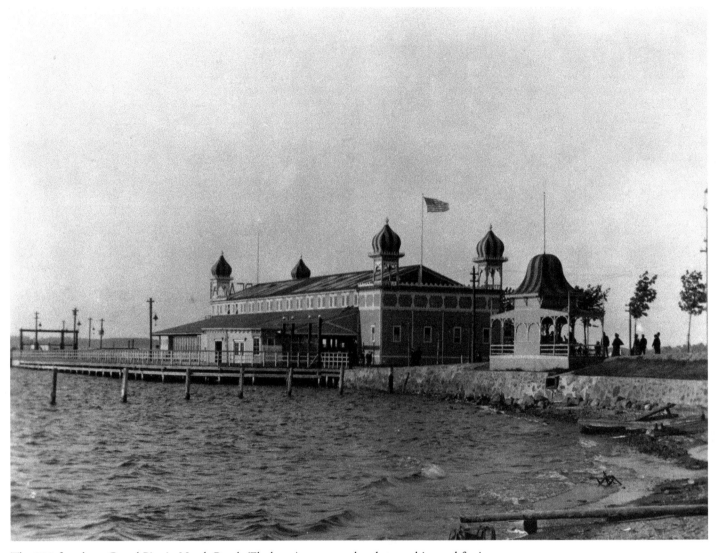

The 300-foot-long Grand Pier in North Beach (Elmhurst) accommodated steamships and ferries from upper Manhattan, the Bronx, and eastern Queens. The fanciful pavilions, which were part of the casino resort atmosphere and featured food and live music, could accommodate 2,000 people. LaGuardia Airport now encompasses much of the original North Beach area.

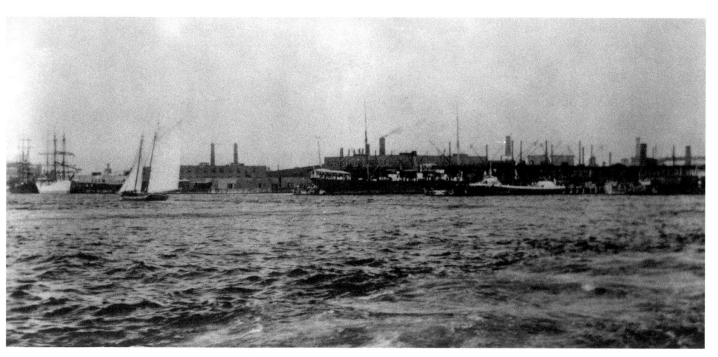

This view from 1895 illustrates the smokestacks and shipping ports that made Long Island City the industrial center of Queens. Today the area remains industrialized, although in recent years it has become a fashionable neighborhood of residential lofts in former factory buildings, and high-rise condominiums with views of the Manhattan skyline.

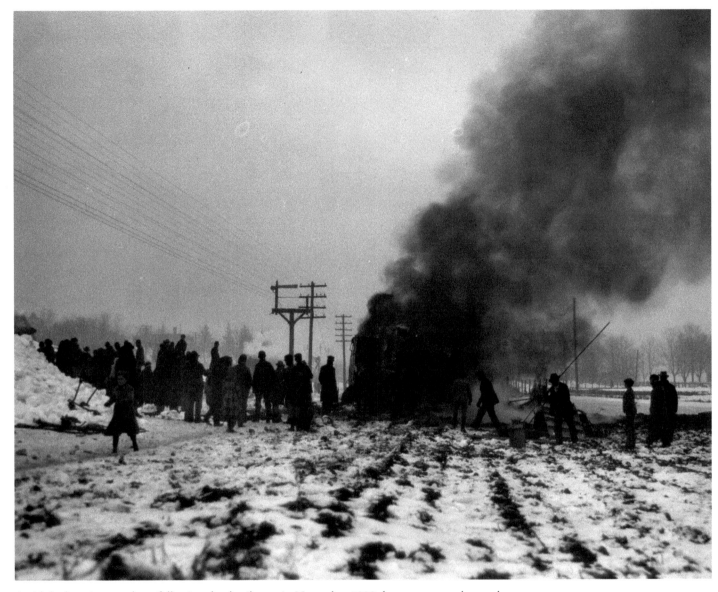

Amid the burning wreckage following the derailment in November 1898, large groups gather at the site, in Queens Village, on what is now the eastern border between Queens and Nassau counties.

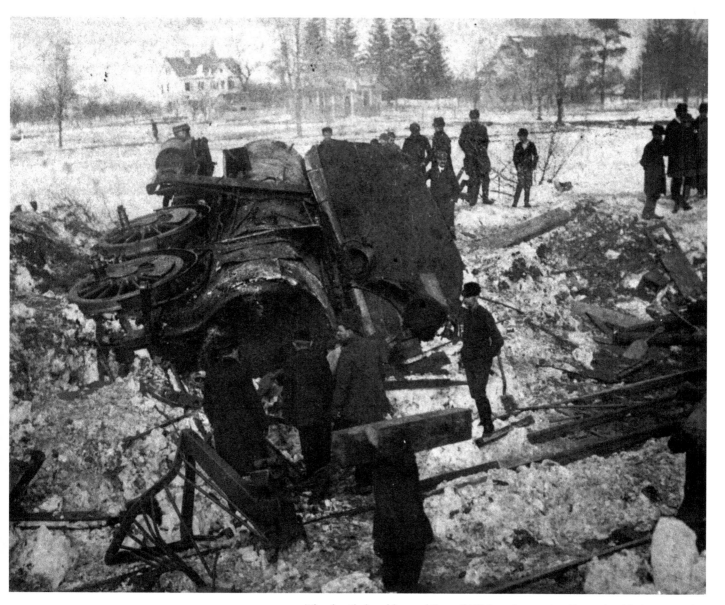

The derailed and burned Russell Wedge plow engine lies on its side in utter ruin.

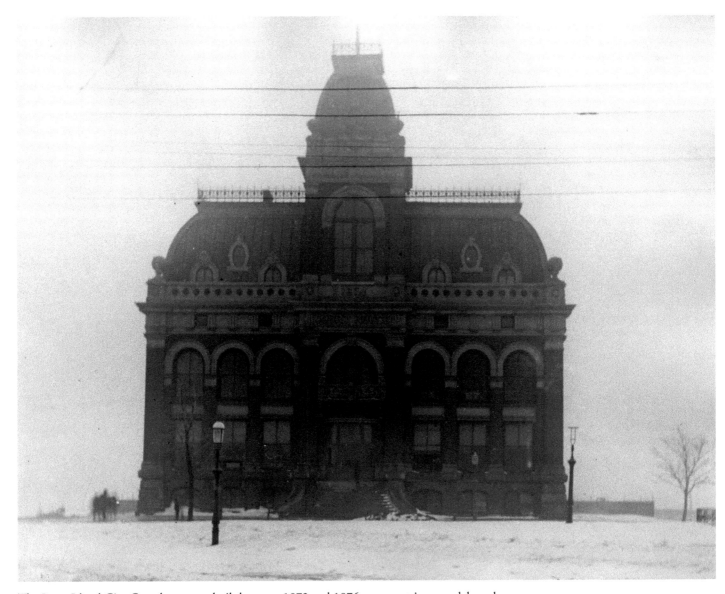

The Long Island City Courthouse was built between 1872 and 1876—overcoming scandals and budget overruns. The building was built in the French Empire style and stood more than two stories tall. Gutted by a fire in 1908, it was redesigned by Long Island City architect Peter M. Coco, who replaced the original design (seen here in 1899) with neoclassical elements. The courthouse remains in use by the New York State Unified Court System today for hearings in Queens County.

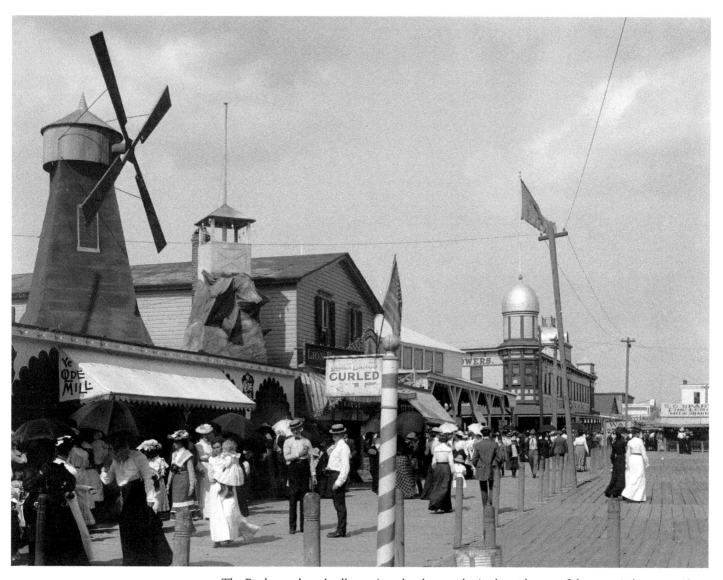

The Rockaway boardwalk continued to be popular in the early part of the twentieth century. Seen here in 1900 is an establishment called "Ye Olde Mill"—perhaps built to give visitors a sense of "old Queens," which had experienced significant changes in the past decade.

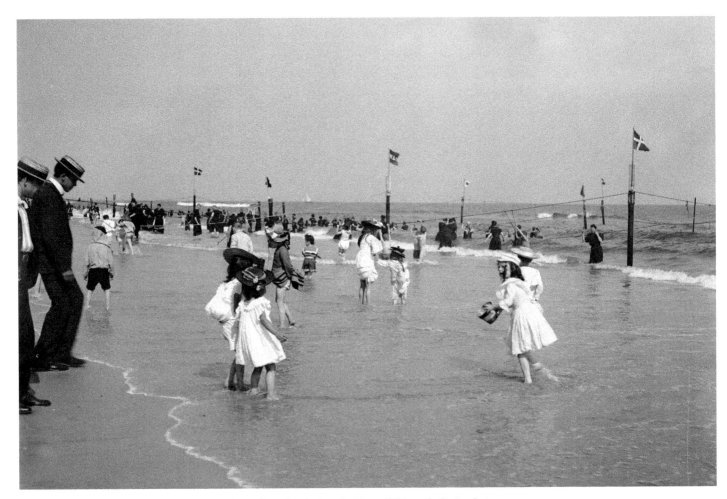

In the early twentieth century, Americans dressed up for the beach. Here children frolic in their Sunday best (minus stockings and shoes) while adults watch over them. The ropes visible in the image were strung out into the surf to assist the able-bodied with rescues, since beachgoers often did not know how to swim and the undertow could be dangerous.

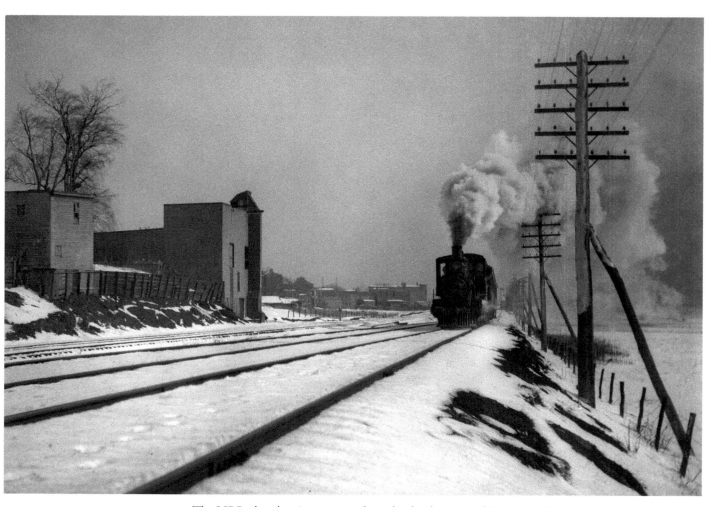

The LIRR played an important role in the development of Queens in the twentieth century. Seen here in the winter of 1900 is a 4-4-0 engine, carrying both passengers and freight from Long Island City to points east.

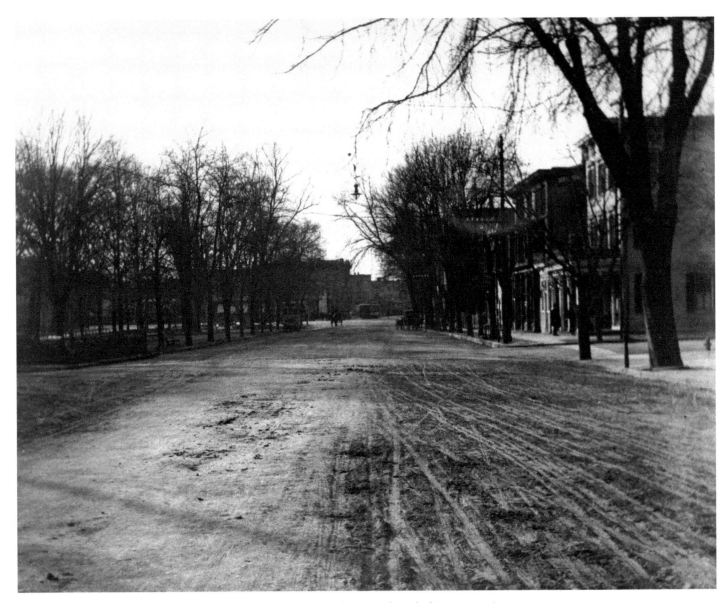

A view of Flushing's Broadway looking west. Since renamed Northern Boulevard, this was a main street, bisecting the borough and continuing into Nassau County. To the far left of the frame in an area known as Flushing Greens is a Civil War monument, erected in 1866 as a tribute to the men of Flushing who perished fighting for the Union. Daniel Carter Beard Square is located today in the wooded area visible at left.

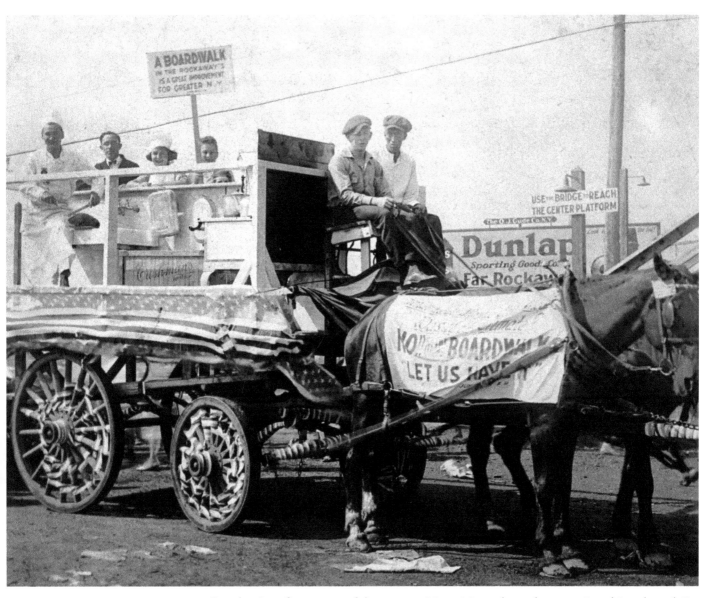

In a showing of some turn-of-the-century civic activism, a horse-drawn carriage drives through Far Rockaway in 1900. The signs push for the Rockaway boardwalk, which served the peninsula for 80 years with an amusement park and other attractions complementing the nation's largest urban beach.

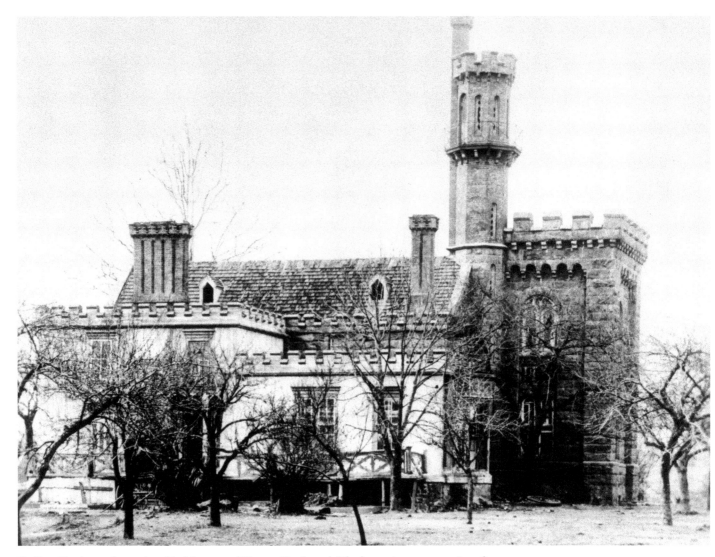

Bodine Castle was located at 43rd Street and Vernon Boulevard. The house is representative of country villas once built in the riverside resort of Ravenswood, Long Island City, by wealthy New Yorkers. The structure fell into disrepair in the twentieth century and was demolished in 1966, when ConEdison began building its massive power plant.

THE BRIDGE TO UNSTOPPABLE PROGRESS

(1900–1929)

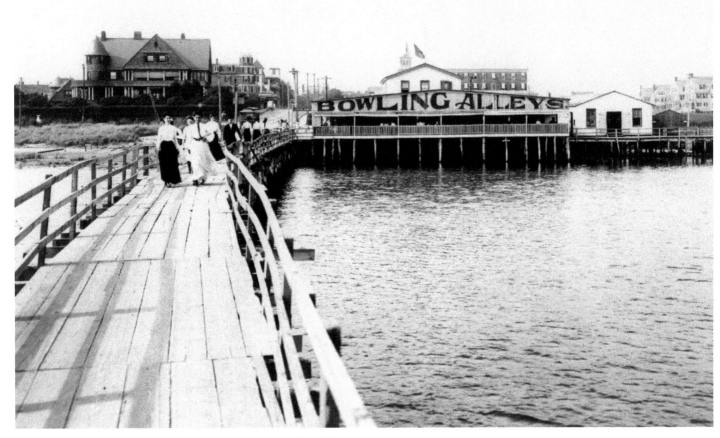

A pier extends into the waters at Far Rockaway around 1902. With the railroad running out to the Rockaways, "New York's Playground" was opened up to new leisure seekers, from the wealthy to the working man, as well as an influx of new locals who worked at the hotels, restaurants, and in the building trades. Visible in the background is the Central Park Bowling Alleys.

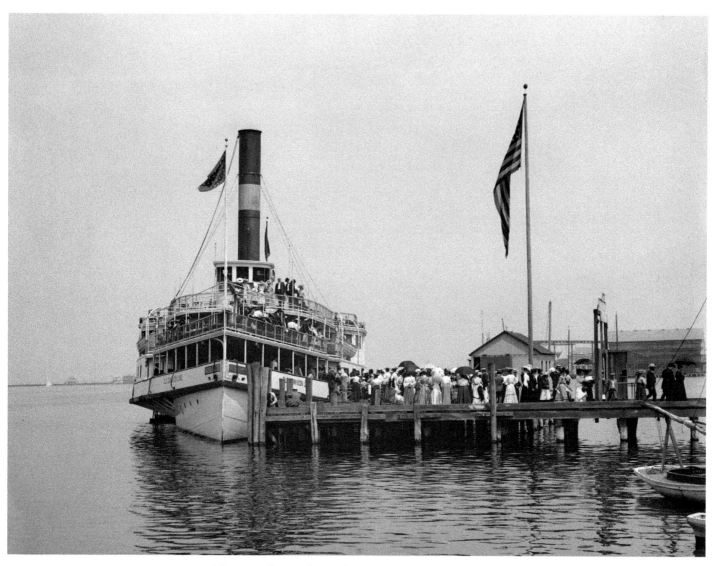

The steamship *Mobjack* takes on passengers at Rockaway Island early in the new century. Although Rockaway is actually a peninsula, there were no bridges for visitors and new residents to travel over until the late 1930s. Steamships thus served as an important conduit.

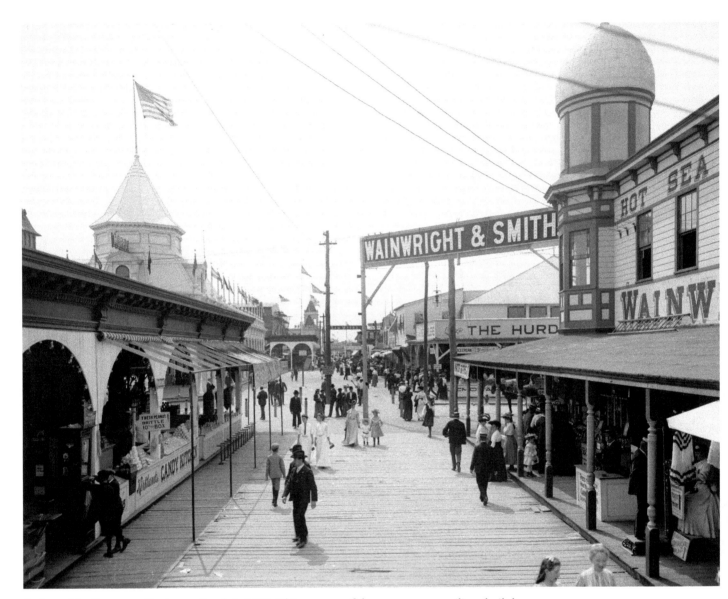

A view of the Bowery at Rockaway Beach in 1903. This was one of the amusement pavilions built by developer William Wainwright. The pavilions included dancing, dining, bars, and bathing areas, and formed some of the first streets in Rockaway, stretching from Rockaway Beach Boulevard across the boardwalk to the shore.

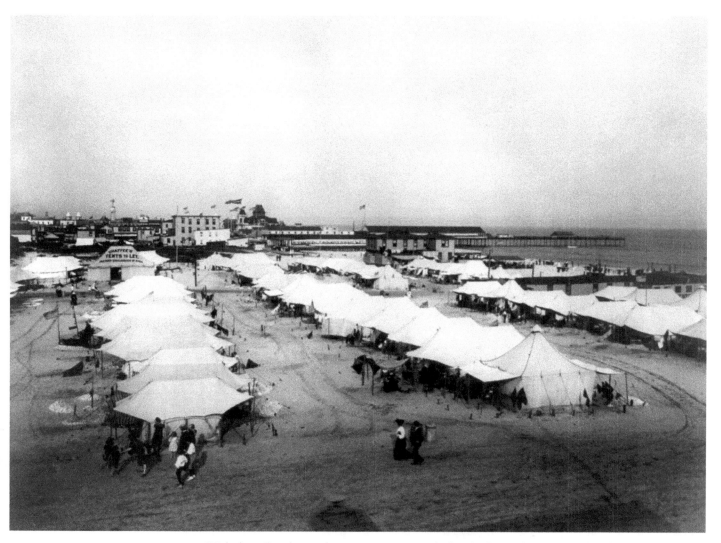

With the railroad providing greater access to the beach, the working man and middle class flocked to "tent cities" like these, which provided low-cost camping on the Atlantic shores for those who could not afford boardwalk hotels. Many families would rent a tent for the entire summer and return to the same camp each year.

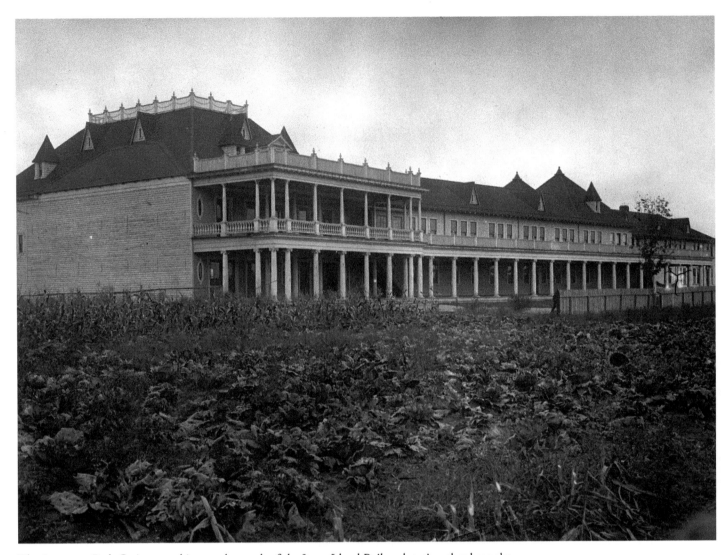

The Interstate Park Casino stood just to the south of the Long Island Railroad station that brought scores of people to the Rockaway Peninsula. Developers had plans to rival Atlantic City far to the south, but were unsuccessful. This photograph shows the casino in 1904 and a large vegetable garden in the foreground filled with cabbages and cornstalks.

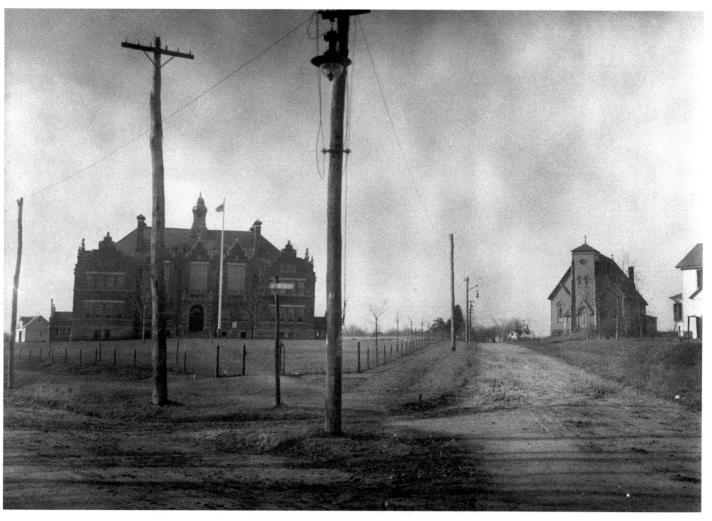

To the left is Public School 34, across from St. Joachim and Anne Catholic Church in Queens Village. Both structures were built on farmland at the end of the nineteenth century. This photograph taken in 1905 shows the great open spaces that still existed in Queens in the early years of the twentieth century, but the borough quickly lost its rural character as development continued over the next two decades, when Queens Village was part of a housing boom.

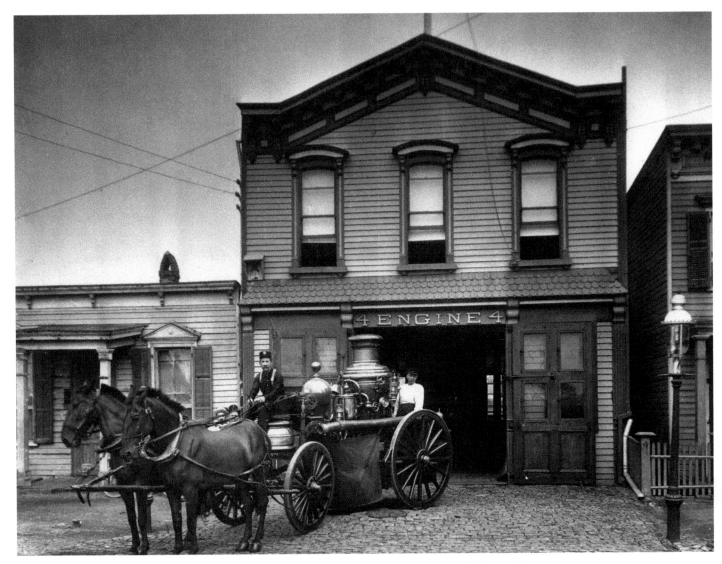

Fire fighters with Maspeth Steamer Engine No. 4. Despite bitter resistance, in 1898 once the boroughs were unified as part of New York City, fire department volunteers were replaced by professionals after insurance companies lobbied the governor. Seen here in 1908, this steam pumper is representative of the types of equipment available in the era to fight blazes across the city. As the internal combustion engine gained sway in the next decade, horses and steam would give way to motorized fire engines and equipment.

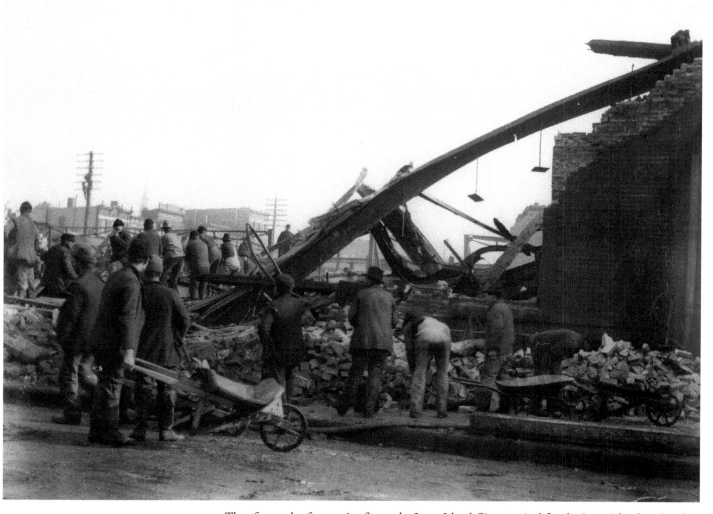

The aftermath of a massive fire at the Long Island City terminal for the Long Island Railroad in December 1902. According to news reports at the time, employees had to jump from the windows to escape, although there was only one injury reported. The fire was said to be so intense that the red-brick building collapsed on itself within 30 minutes, despite every engine from Brooklyn, Queens, and Manhattan being called in to assist. The station had earlier been rebuilt in 1891 at a cost of $200,000 after a fire destroyed the terminal, which stood at the end of the main line. The newer terminal was rebuilt in 1903.

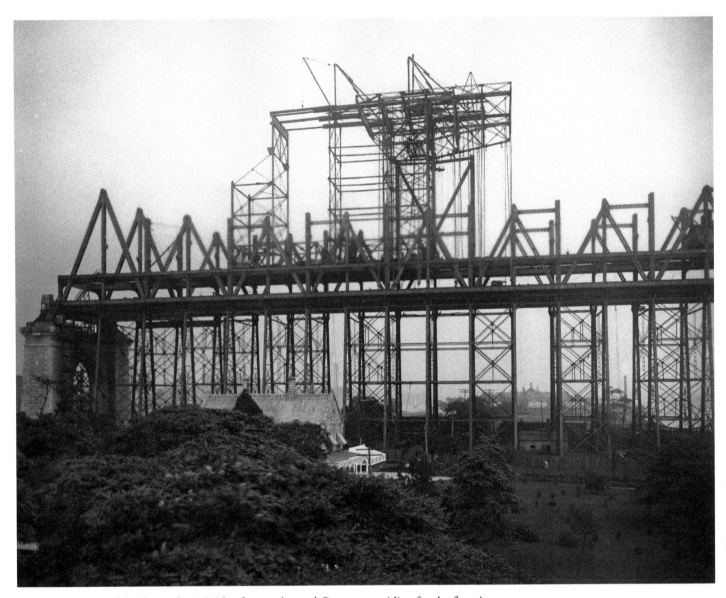

The construction of the Queensboro Bridge forever changed Queens, providing for the first time a direct link over the East River to Manhattan. Construction is shown here in 1906, as the bridge crosses Blackwell's Island (Roosevelt Island) in the center of the river. The view is to the north, toward the Bronx, with Queens on the right and Manhattan to the left. The bridge would be completed in 1909 at a cost of $18 million and 50 lives lost.

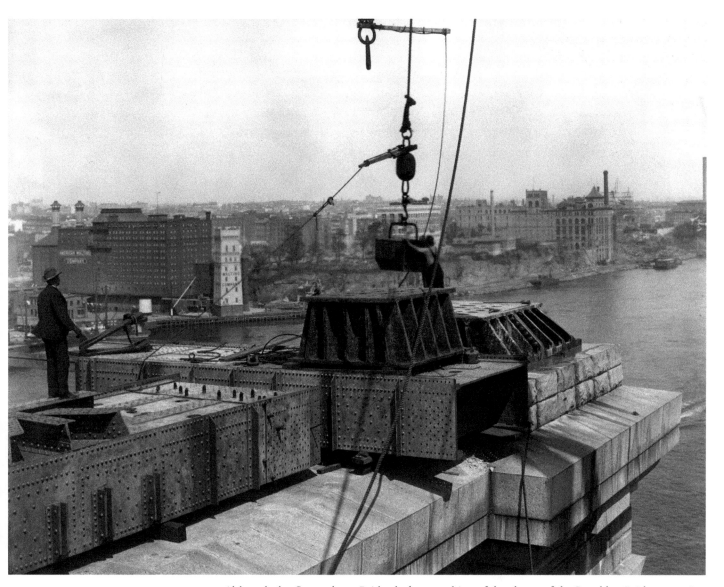

Although the Queensboro Bridge lacks something of the charm of the Brooklyn Bridge spanning the same river just a few miles to the south, its construction ended the isolation of Queens from Manhattan. The bridge remains the only overland crossing directly between the two boroughs. As evidence of the backseat Queens takes to "the City," New Yorkers today commonly refer to the bridge as the "59th Street Bridge" for the Manhattan street the bridge connects to, despite the bridge's official name.

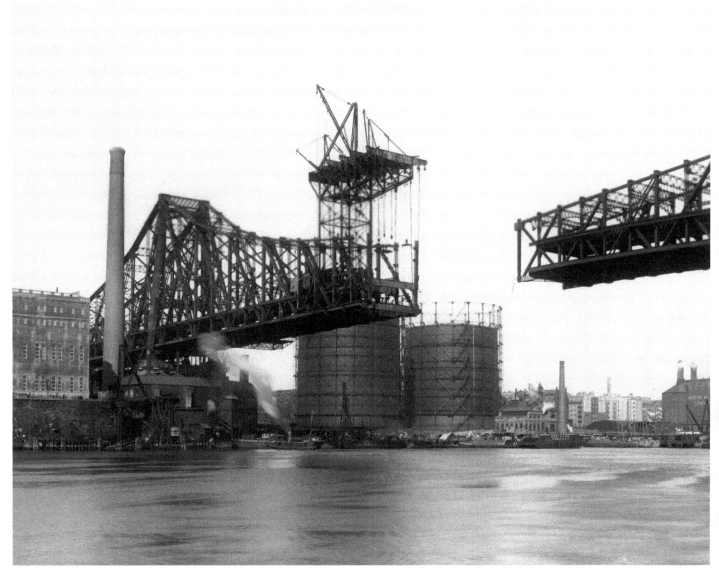

About a year prior to the opening of the Queensboro Bridge in March 1909, the span of the bridge is nearing completion. The bridge is a double-cantilever, two-level bridge, with one span on either side of Roosevelt Island, to which it also connects. This photograph was taken from the island.

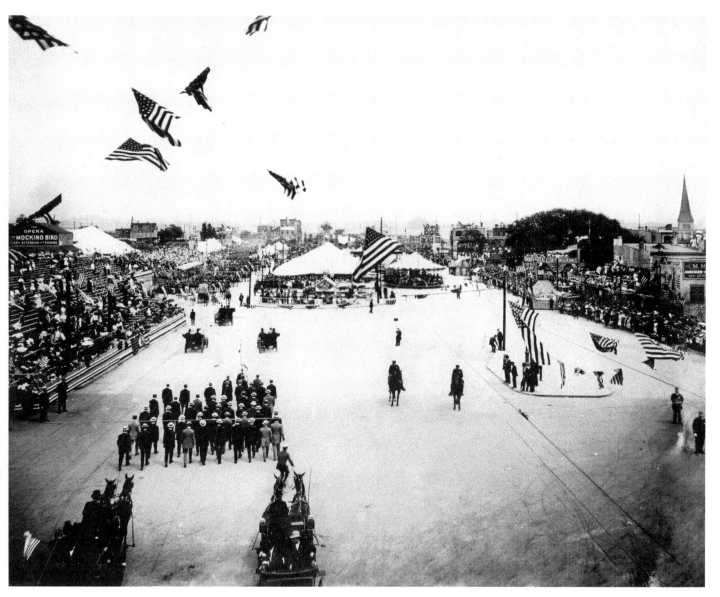

Opening Day ceremonies for the monumental bridge in June 1909 were held with great fanfare, as Queens was finally united with Manhattan, perhaps the most important event in the history of the borough. The base of the Queens side of the bridge was transformed into Queensboro Plaza, seen here looking east from the bridge. The plaza was used as parade grounds for the ceremonies.

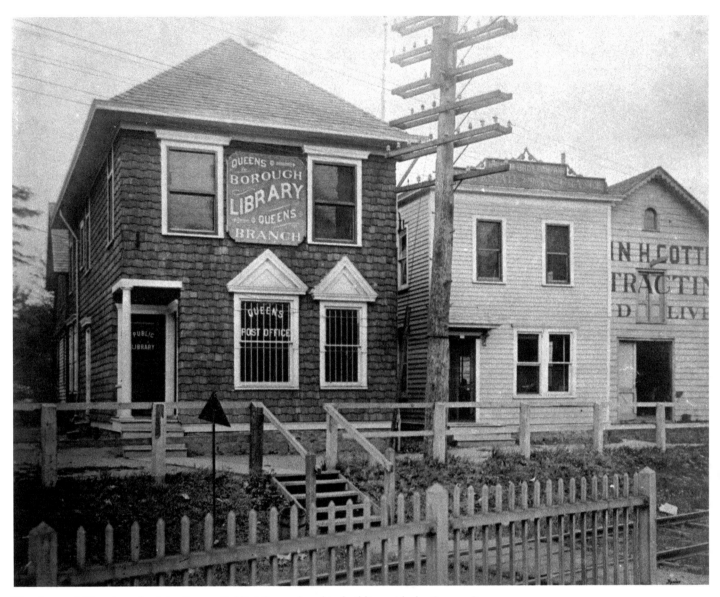

The Queens Village branch of the Queens Public Library shared its building with the Queens Post Office, shown here in 1910. Because the population of the borough was still spread out across the large area of the borough, the libraries were often operated from storefronts and stocked by a traveling library system—which was so popular that it eventually led to permanent branches being established across Queens.

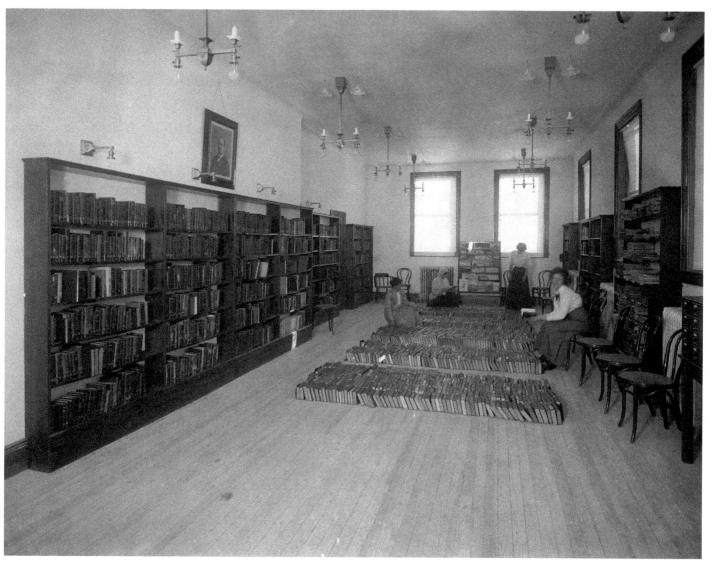

Librarians are seen preparing books for the stacks in 1910. The Queens Borough Public Library is one of the largest in the United States and is separate from both the New York Public Library and the Brooklyn Public Library. The library was consolidated in 1901 by New York City, which combined the various libraries from the towns and villages that existed in Queens County prior to its incorporation as a borough of New York City.

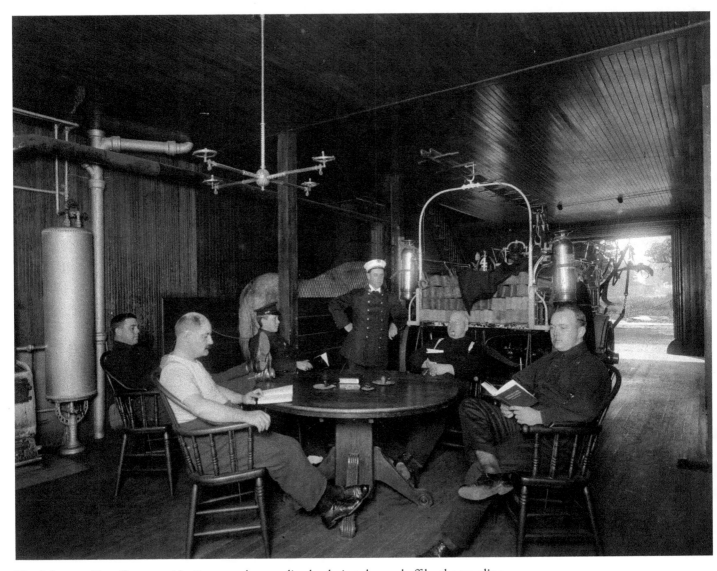

Fire fighters at Hose Company No. 2 are seen here reading books just dropped off by the traveling library service, while in between alarm runs. The fireman at right is holding a book titled *Motor-Car Principles*—perhaps dreaming of trading the horses for a newfangled motorized fire engine.

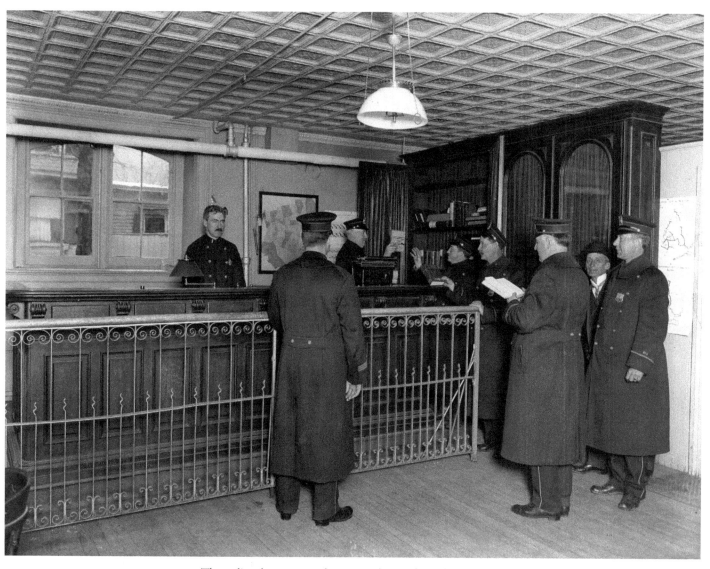

The police department also received visits from the traveling library. This precinct appears to have its own lending library behind the main desk.

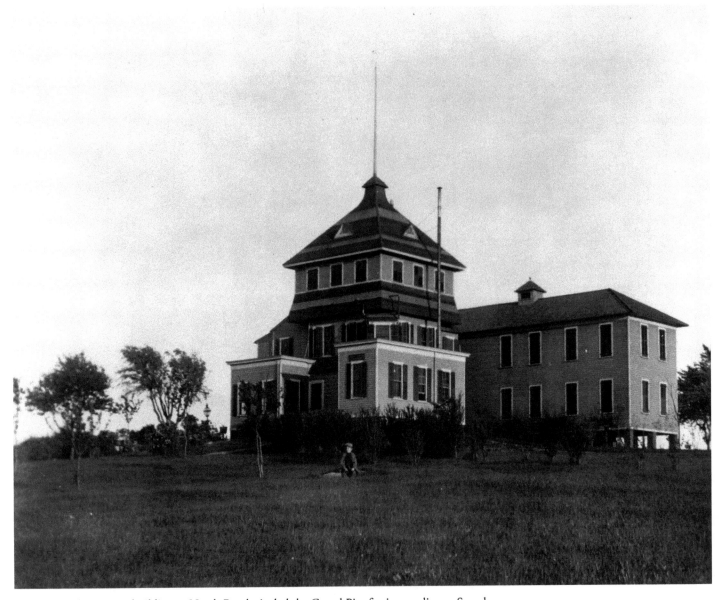

The 74th Sub-Precinct building at North Beach rivaled the Grand Pier for its stateliness. Seen here, the station operated mainly in the summer months and sat on a landscaped property befitting the resort area it served and protected. North Beach was also called "Bowery Bay" as part of a marketing plan devised by its main investors, piano maker William Steinway and brewer George Ehrets.

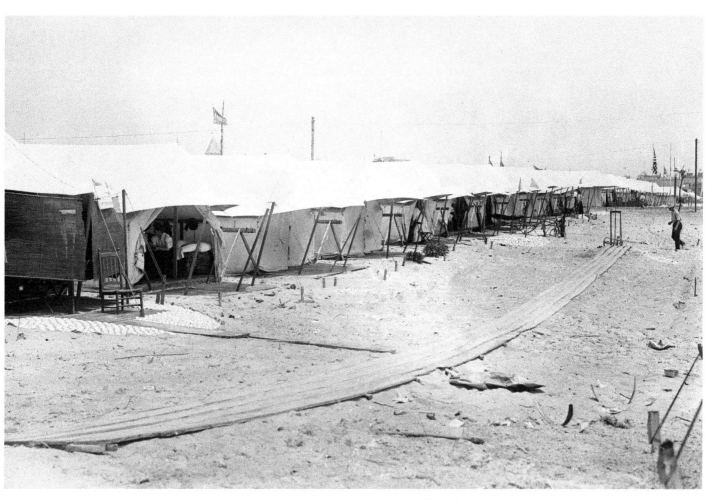

A close-up look at one of the many tent cities that filled the beaches of Rockaway along the Atlantic in the summer, providing respite for New York's everyday folks. The makeshift boardwalk laid across the sand made walking around the camp much easier.

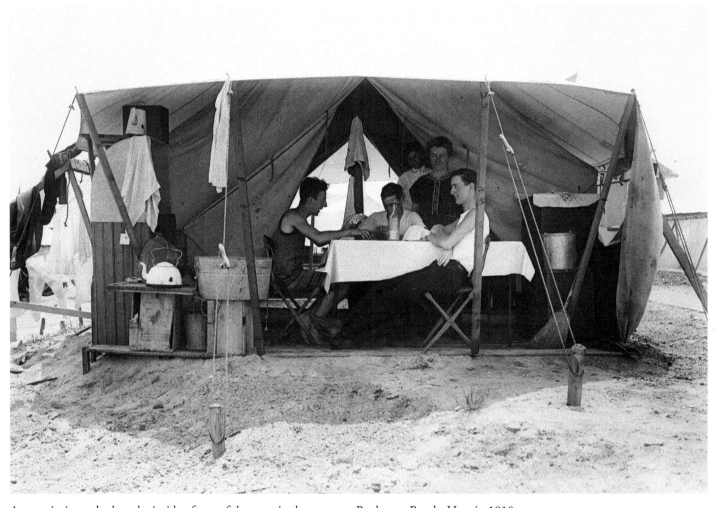

A more intimate look at the inside of one of the tents in the camps at Rockaway Beach. Here in 1910 a family enjoys a card game on the sand—complete with all the refinements of home, including a white tablecloth and a teakettle.

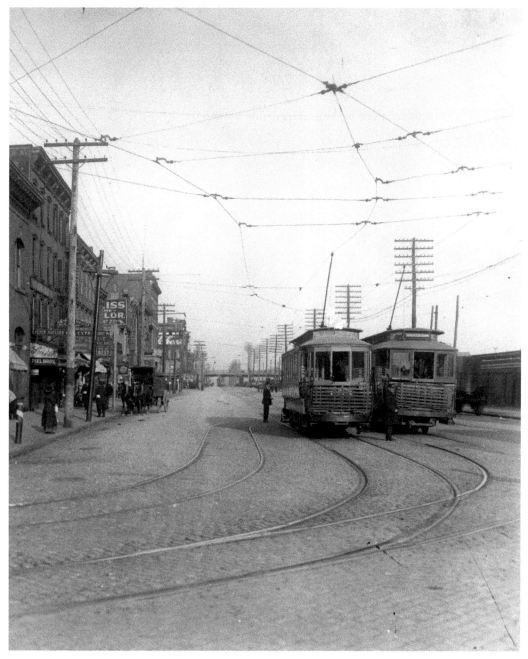

In sharp contrast to the rustic Rockaway Beach camps, two New York & Queens Company trolley cars ply Borden Avenue (here facing east at Front Street) in Long Island City, on the opposite side of the borough. The sky is crisscrossed with electrical and telephone lines, demonstrating the technological progress the borough experienced after the turn of the century. To the left of the frame are a number of beer gardens that once did business in the area.

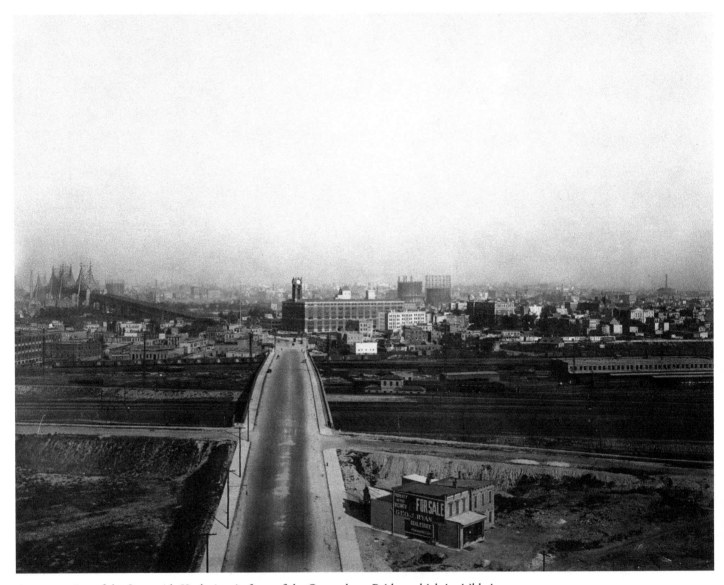

A western view of the Sunnyside Yards, just in front of the Queensboro Bridge, which is visible in the left background of the frame. The yards still exist and are in use by the Long Island Railroad and Amtrak. In some respects, the area today retains an industrial charm, although high-rises punctuate parts of the skyline, including the massive glass Citibank Building that stands across from the Long Island City Courthouse.

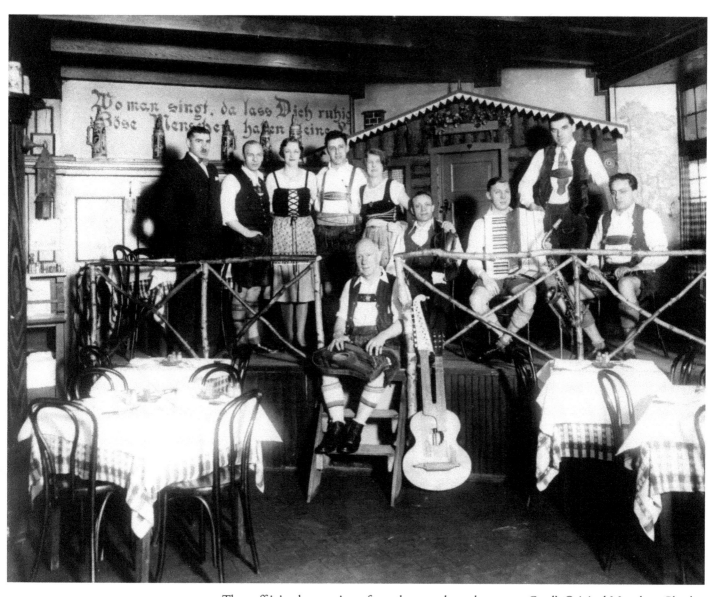

The staff joined entertainers for a photograph on the stage at Gostl's Original Munchner Platzl, a traditional German Hofbrauhaus that celebrated the Bavarian heritage of Long Island City in 1910.

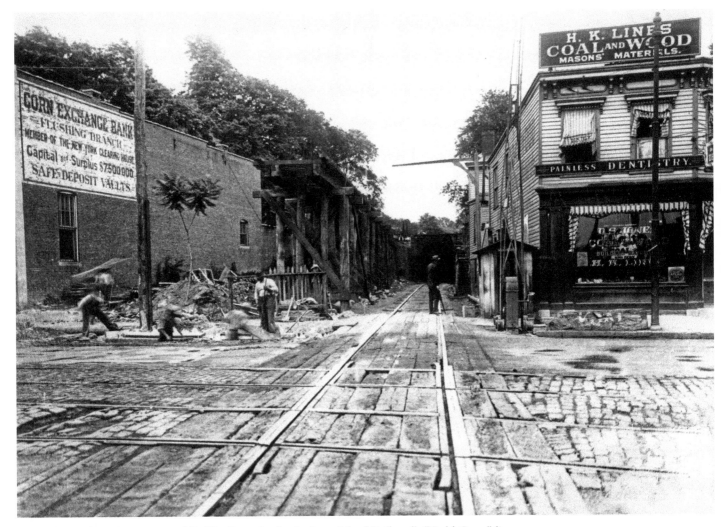

Made famous by F. Scott Fitzgerald's *The Great Gatsby,* the Long Island Railroad's "Gold Coast" line still runs along the North Shore of Long Island, through the Queens neighborhoods of Woodside, Flushing, Bayside, Douglaston, and Little Neck. Seen here in 1912 is the crossing at Main Street, in Flushing.

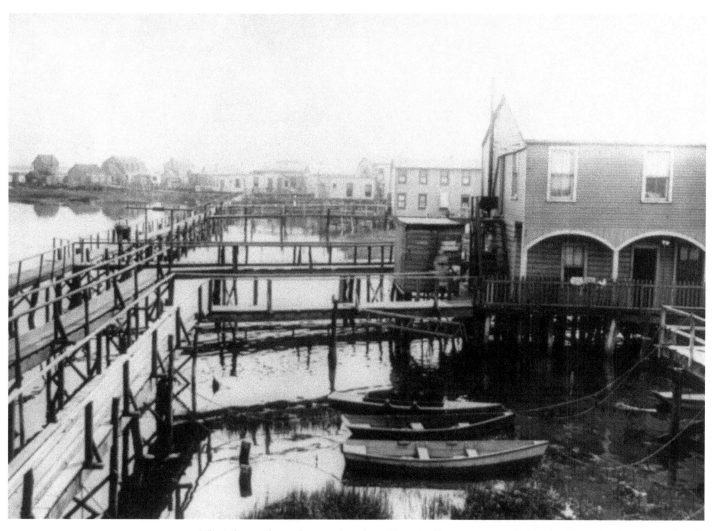

The inlets and marshes on the edge of Jamaica Bay were part of a housing boom in the second decade of the twentieth century. This scene from around 1915 shows houses built on stilts into the bay, with gangways connecting the homes and the mainland, rather than sidewalks. Small boats are moored near some of the houses. Communities like this one still exist in south Queens, west of John F. Kennedy Airport.

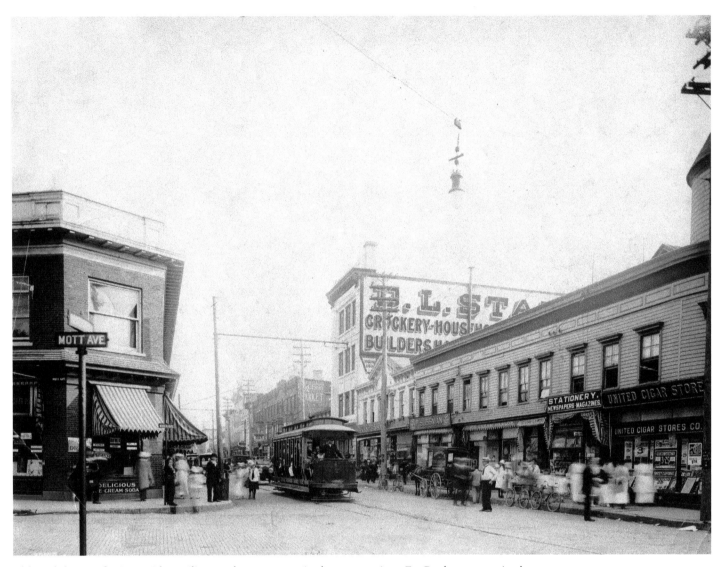

Although known for its seaside pavilions and amusements in the summertime, Far Rockaway was (and is) a community of locals who are accustomed to living on an isolated strip of land on the Atlantic Coast, yet still within the borders of New York City. Pictured here is a busy day in 1916 along Mott Avenue at the intersection of Central Avenue.

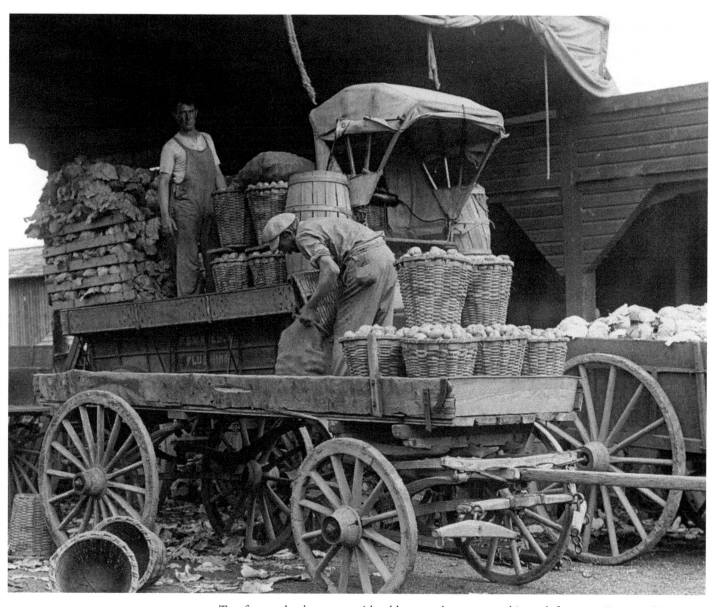

Two farmers load a wagon with cabbages and potatoes at this truck farm near Jamaica, Queens, in the 1910s. The borough was still known for agricultural production in the years leading up to the encroachment of suburbia.

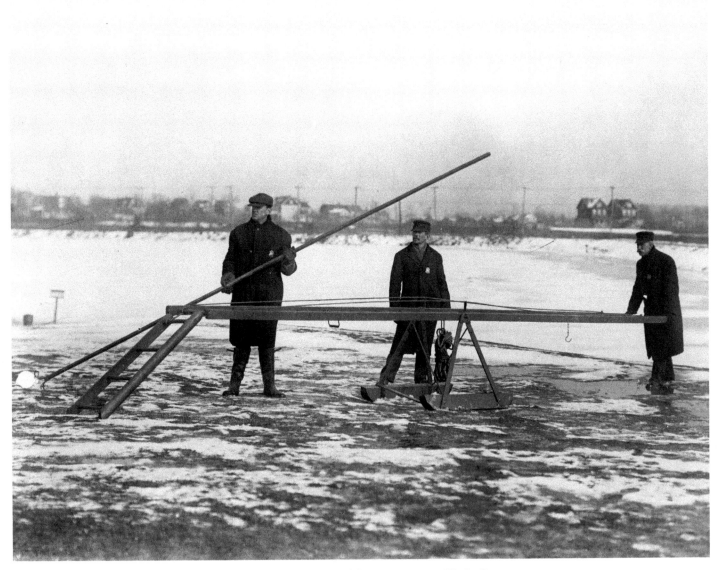

On a frozen pond in Queens stands George Hanlon, the foreman of the Department of Parks for Queens. Hanlon and crew were on hand with an apparatus designed to rescue hapless skaters who fell through the ice.

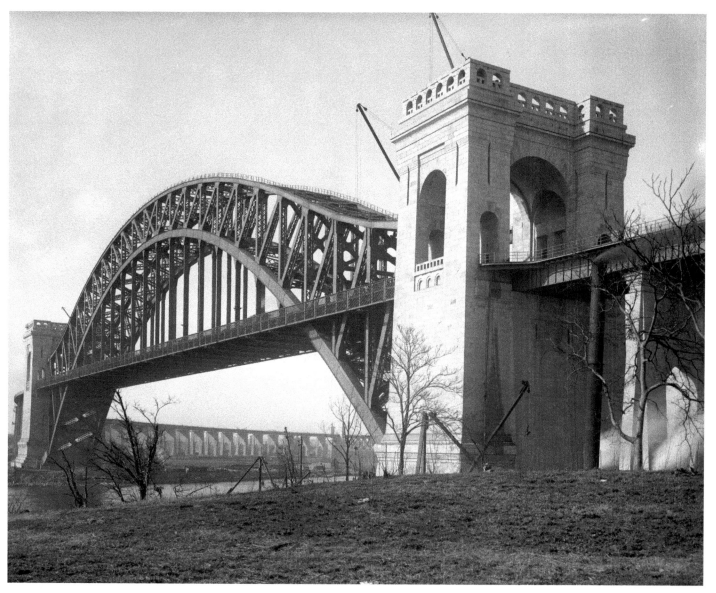

The Hell Gate Bridge opened in Astoria in 1916 as a railroad bridge spanning an area of the East River known as Hell Gate. The bridge was designed by Gustav Lindenthal, who had completed work on the Queensboro Bridge some years earlier. With little formal education and lacking a degree in civil engineering, Lindenthal had taught himself to build bridges, immigrating to America to find the opportunity denied him in Europe.

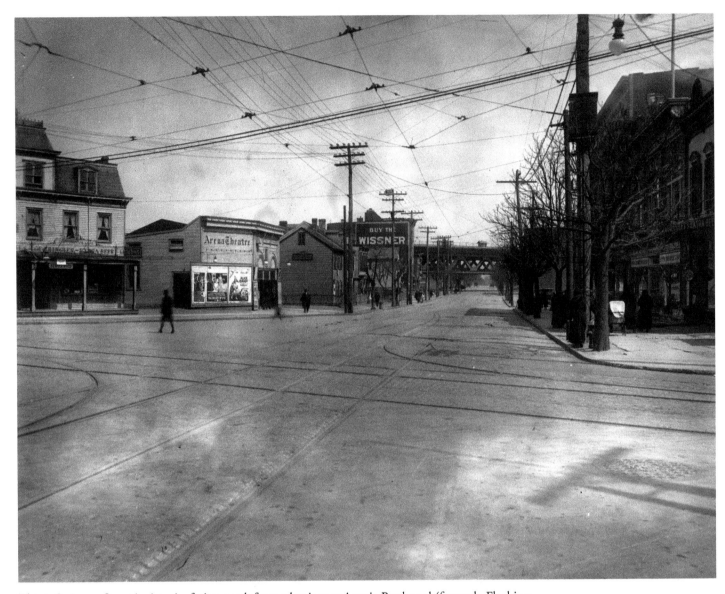

This is Steinway Street in Astoria, facing north from what is now Astoria Boulevard (formerly Flushing Avenue). To the left is the Arena Theatre, one of the first cinemas to open in Queens during the silent film era. The large sign to the north advertising the "Wissner" is likely for the Wissner Piano Company—strategically placed on the street named for the founder of the rival Steinway & Sons brand.

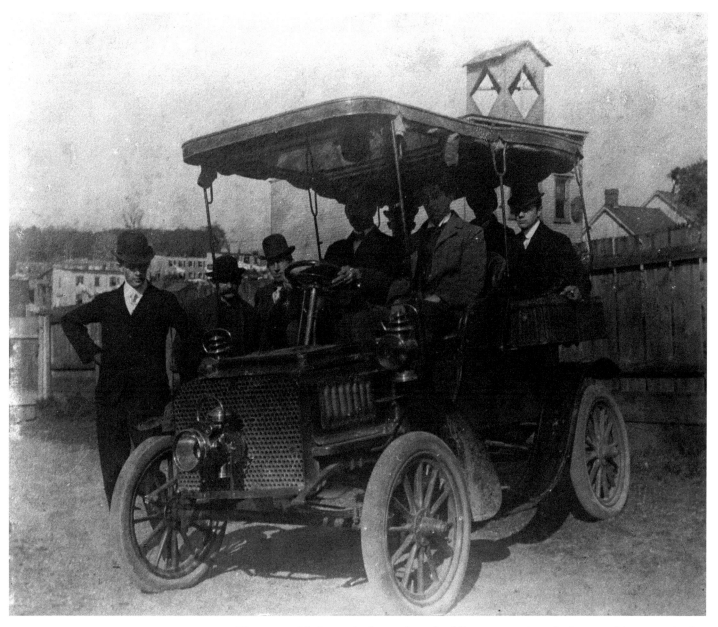

The automobile increasingly supplanted public transportation, the horse-and-buggy, and other conveyances, giving commuters and travelers greater mobility across the vast borough.

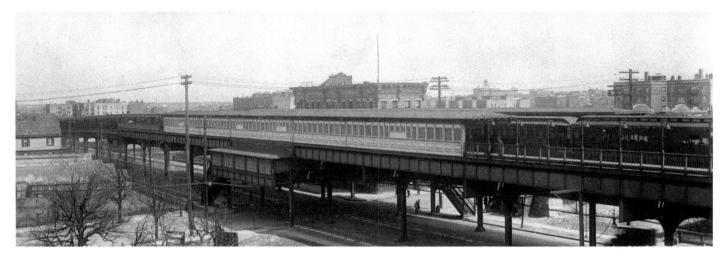

The west side platform of the Broadway Avenue subway station in 1922. These elevated tracks made
rapid transit service possible and are still in use today.

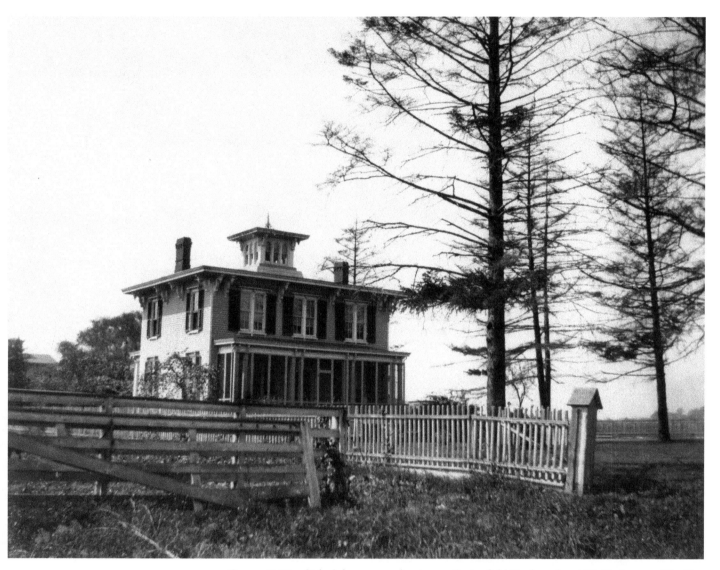

George E. Van Siclen's house on what is now Springfield Boulevard and Hollis Avenue. The Van Siclens were one of the oldest families on Long Island and operated a farm in what was later established as Queens Village. The farmland succumbed to development in the 1920s, when a housing boom sparked the building of large residences for commuters, who established some of the earliest suburban areas of the county.

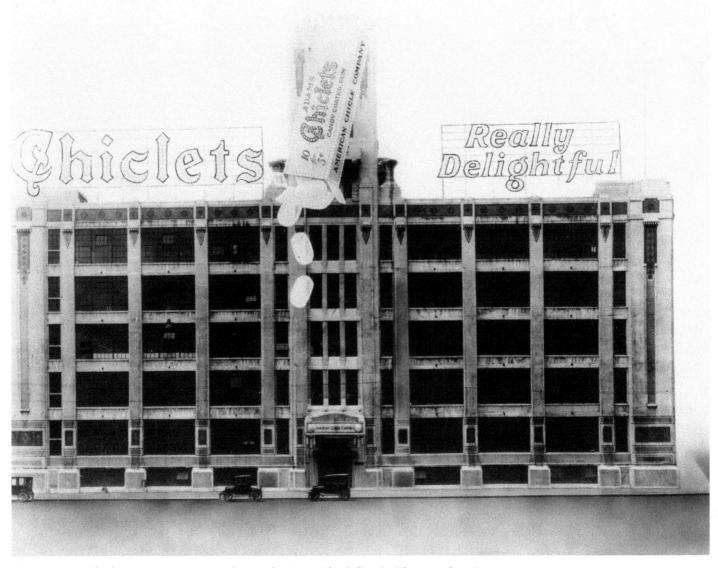

The American Chicle Company at Degnon Terminal in Long Island City (at Thomson Street) displays a new billboard for Chiclets gum in 1923. The building spanned 60 city lots, had an internal courtyard to accommodate railroad sidings, and cost $2 million to build. The company was actually a "chewing gum trust," manufacturing its products for various brands in the United States and importing gum from the Yucatán region of Mexico.

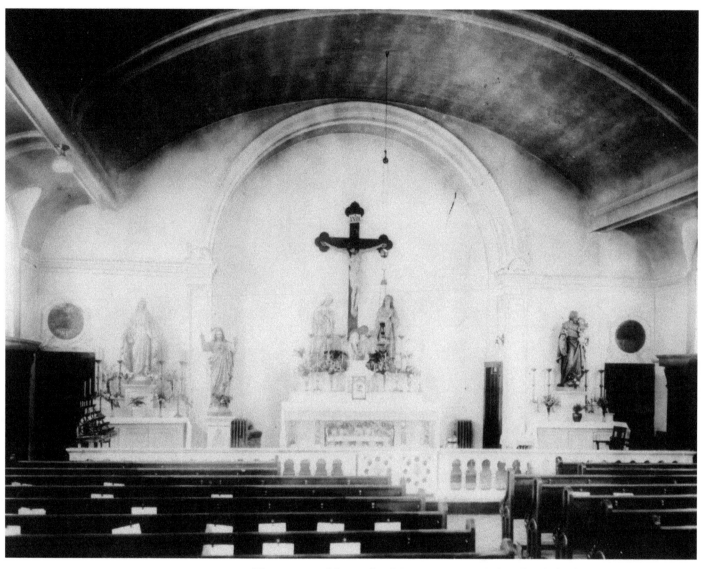

The interior of Our Lady of Grace Roman Catholic Church, built in 1924, located in the neighborhood of Howard Beach—a small peninsula formed by Jamaica Bay to the south, Shellbank Basin to the west, and Hawtree Creek to the east. The northern part of the area was originally a goat farm used to provide skins to glove manufacturer William Howard. He developed the area, which eventually included a pier, casino, railroad station, and beaches—which drew investors and eventually formed enough of a neighborhood to merit building the church.

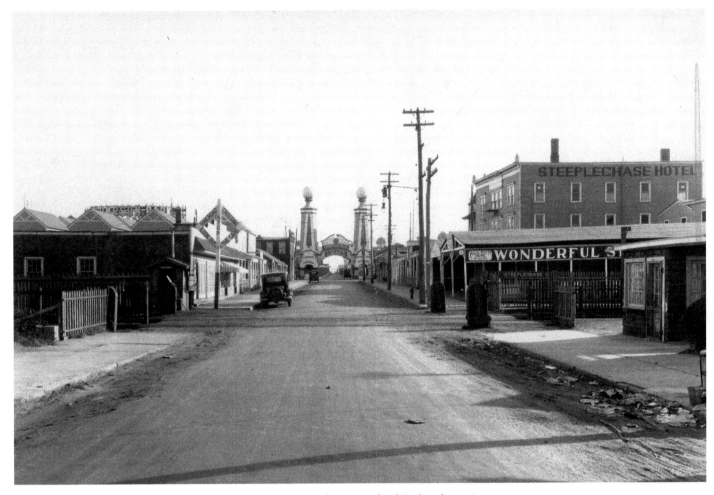

Looking south down Ward Avenue (Beach 98th Street) across the Long Island Railroad crossing, near the Steeplechase LIRR station—named for Steeplechase Park and the Steeplechase Hotel visible in the distance. The stop was also used by the Ocean Electric Railway's trolleys. It was later used by the IND Rockaway Line. Today the Beach 98th Street elevated subway station stands in roughly the same location.

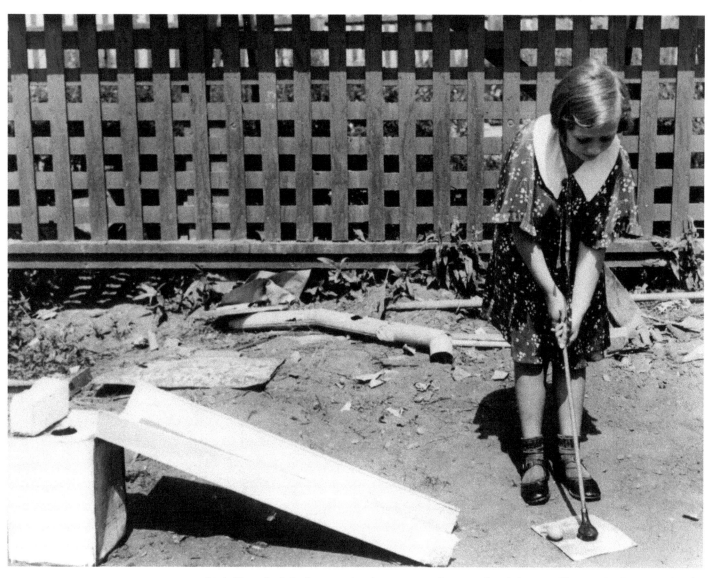

Little Dorothy Messina practices her putt on a homemade miniature golf course in Ozone Park. The neighborhood was originally developed in the late nineteenth century and expanded as the LIRR opened a station east of Howard Beach. In 1914, an elevated railroad line made the area even more accessible for commuters seeking a suburban life. With the expansion of Woodhaven Boulevard all the way to the Rockaways, the area was opened to vehicular traffic and development boomed.

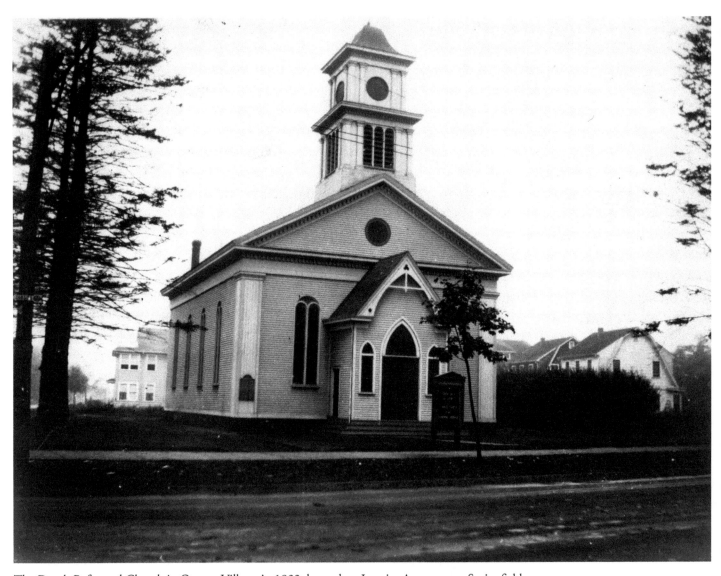

The Dutch Reformed Church in Queens Village, in 1922, located on Jamaica Avenue near Springfield Boulevard. It was founded in 1858 as the Reformed Protestant Dutch Church of Queens, and parishioners included the large Van Siclen farming family.

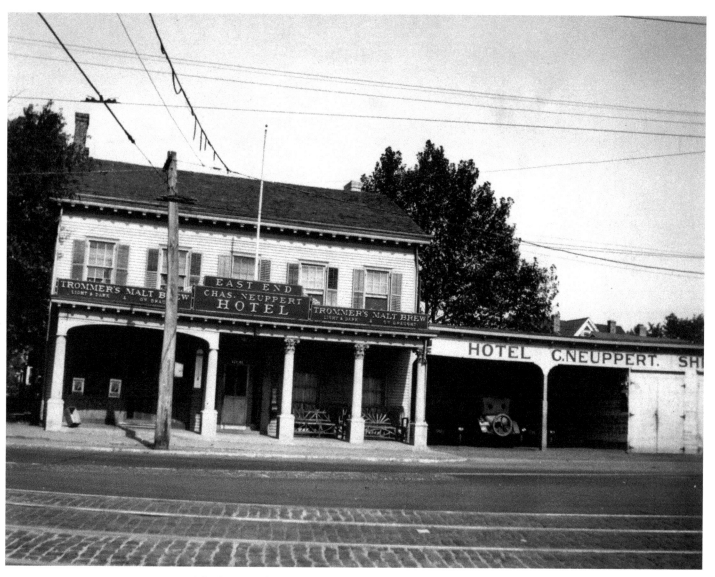

The "East End" generally refers to the eastern tip of Long Island—yet here, a hotel on Jamaica Avenue is named the East End Charles Neuppert—evidence of the Manhattan attitude that Queens was worlds away. The signs advertise Trommer's Malt Brew, a beer brewed in nearby Bushwick, Brooklyn.

The H. C. Poppenhusen House in Queens Village was turned into a hotel in 1896. The mansion stood at what is now the corner of Braddock Avenue and Winchester Boulevard, in front of the Creedmoor Rifle Range. Conrad Poppenhusen was a German immigrant who founded College Point in northern Queens and built the causeway that connected it to Flushing—now known as College Point Boulevard. The Poppenhusen Institute, built in 1868, hosted the nation's first free kindergarten and the building remains in use.

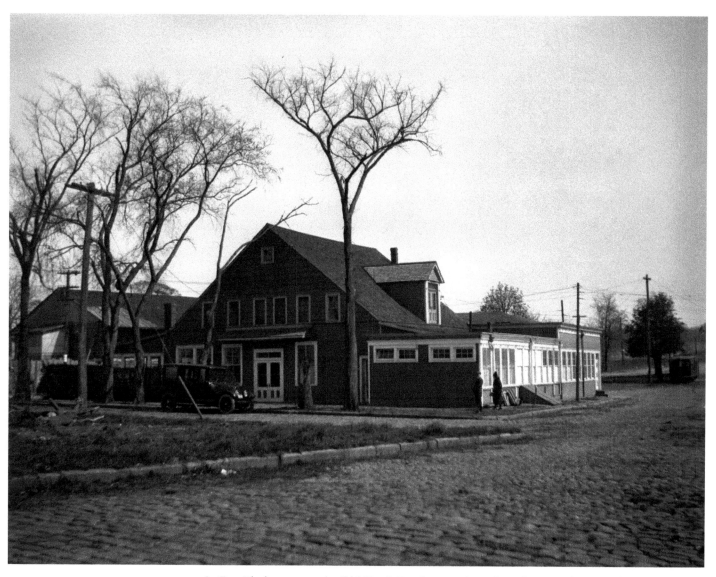

In East Elmhurst, near the Old North Beach area, a large frame house with many additions stands in what was likely a country lane around 1925—if not for the cobblestone streets and the trolley car seen in the distance, clearly identifying this as a quasi-urban neighborhood.

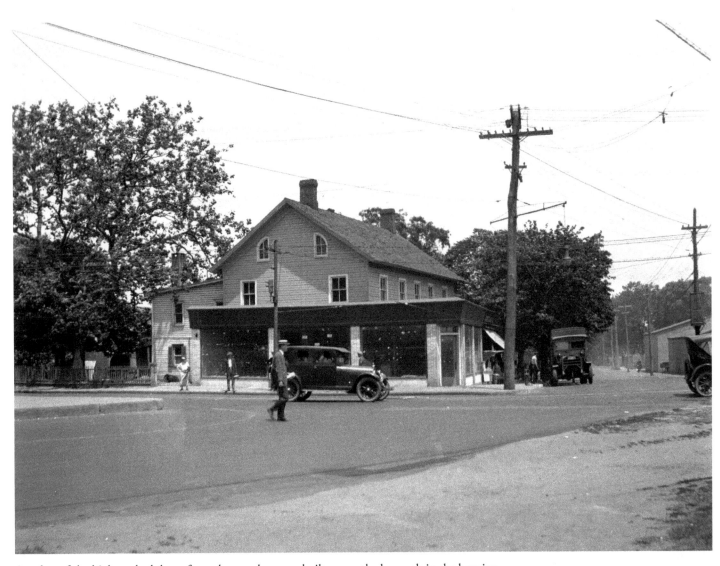

Another of the high-peaked, large frame houses that were built across the borough in the housing boom of the 1920s. This house has not only been extended, but also has a retail establishment and adjacent grocery, well placed on a busy corner with ample foot and automobile traffic.

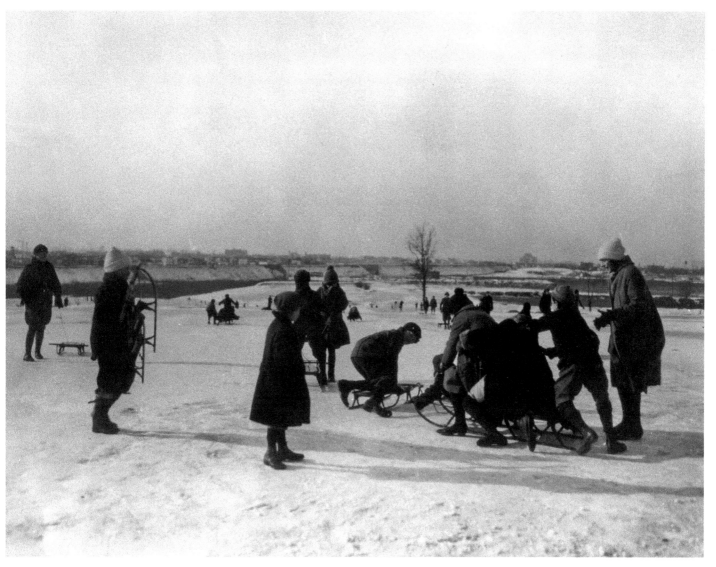

Children take advantage of a snowy day in the open spaces of Jackson Heights in the winter of 1925. Today, the area is densely packed with a mix of residential and commercial buildings as diverse as the population that lives and works in the area.

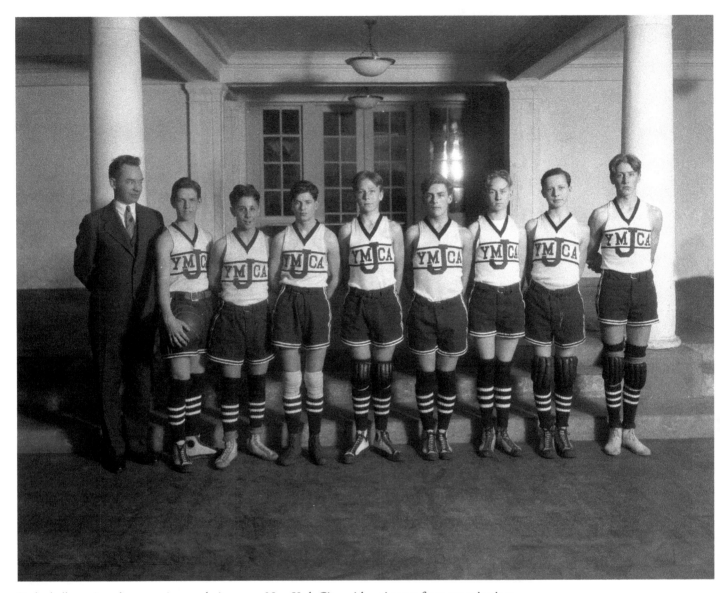

Basketball continued to grow in popularity across New York City, with assistance from organizations like the Y.M.C.A., which sponsored local teams and provided gymnasium space. Here is a group of teenage boys from Queens who were listed as the 1925–26 Y.M.C.A. Champions of Greater New York.

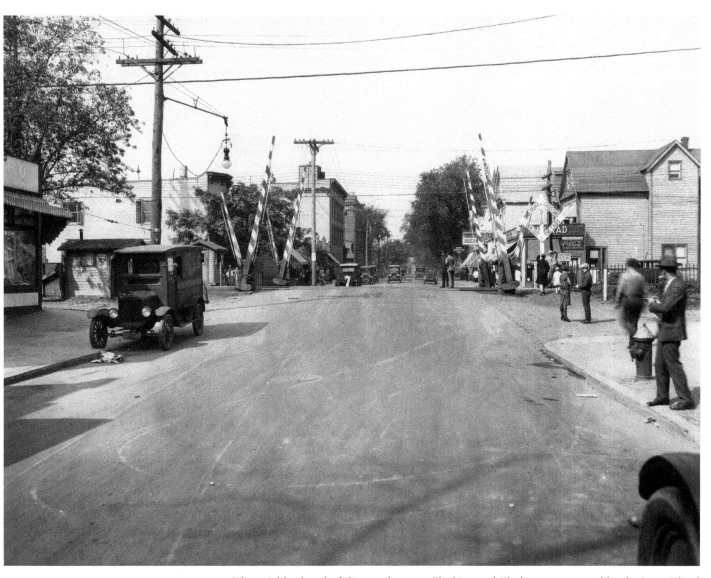

The neighborhood of Corona, between Flushing and Elmhurst, was served by the Long Island Railroad with the Alburtis Street Station crossing near 45th Avenue and what is now 104th Street. The No. 7 elevated subway train has since replaced the railroad, which now bypasses the area between Flushing and Woodside.

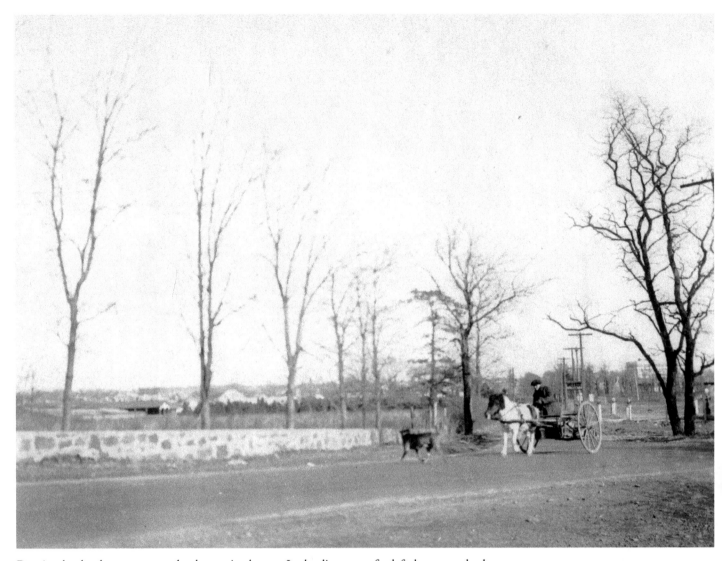

Despite the development, some lands remained open. In the distance at far-left, homes and other development can be discerned, but on this stretch of Braddock Avenue near Springfield Boulevard in Queens Village in 1927, this pony-drawn cart with a dog surveying the road, does not look out of place. The intersection marked the boundary between the Third and Fourth wards of the county, early political divisions.

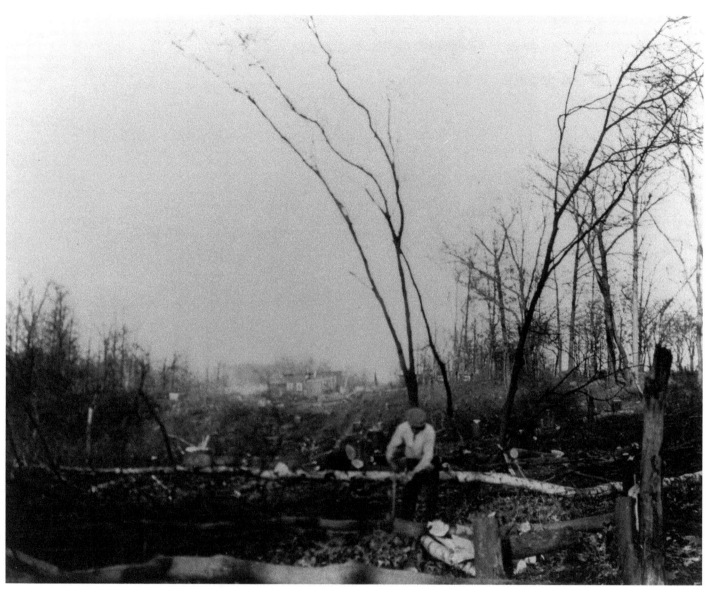

In order to bring greater development to eastern Queens, roads had to be cut through the wilderness, which required crews to clear trees from the forests. This may be an early extension of Hillside Avenue from Jamaica to Hollis and Queens Village.

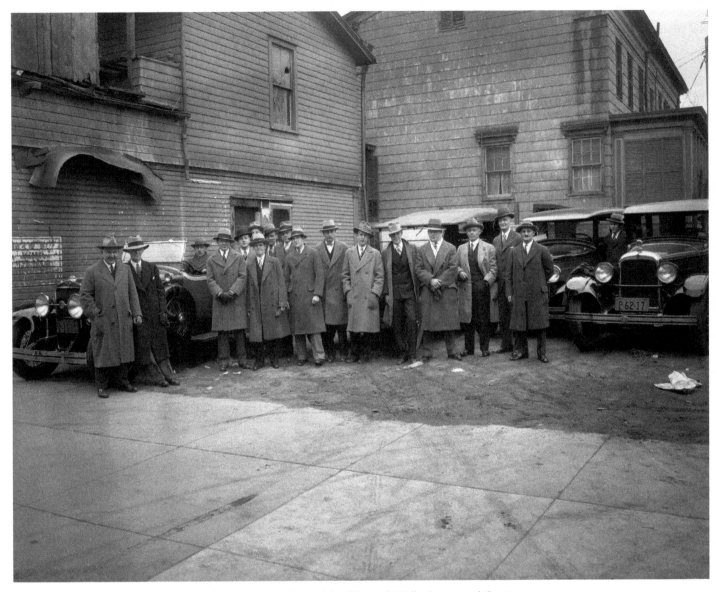

A photograph by the Long Island Press showing Mayor James John "Jimmy" Walker's automobile trip to the Borough of Queens in 1927. Known as "Beau James," the jazz age mayor is seen here touring the city during a time of great prosperity, prior to the 1929 stock market crash.

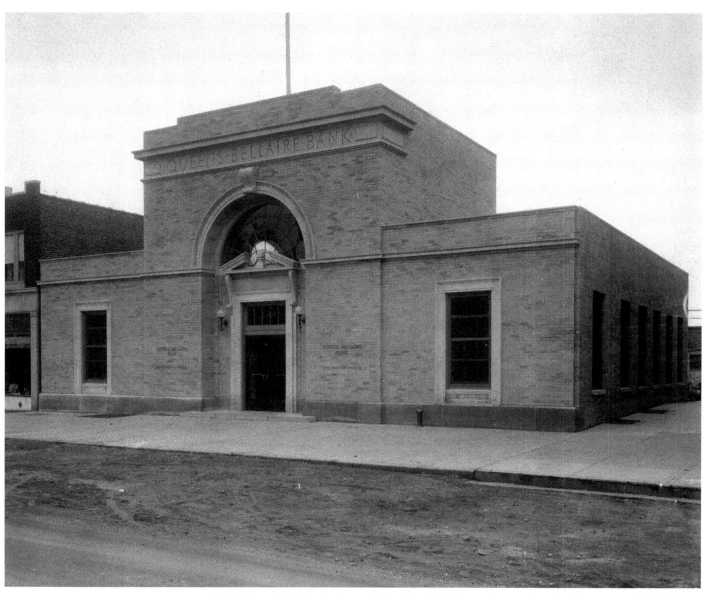

The Queens-Bellaire Bank, established in 1921, is seen here on Jamaica Avenue near 215th Street. Bellaire is a subsection of Queens Village, which today encompasses three zip codes.

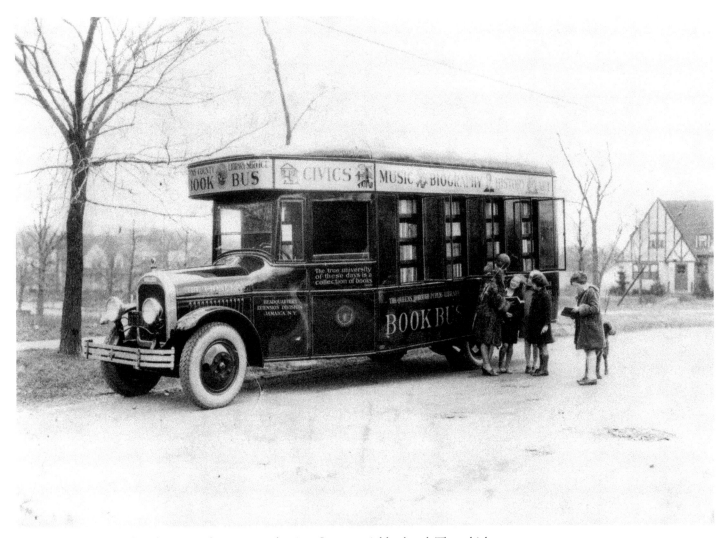

The book bus "Pioneer" makes a stop for young readers in a Queens neighborhood. The vehicle was Queens' first traveling library and featured bookshelves that literally opened to the public for browsing.

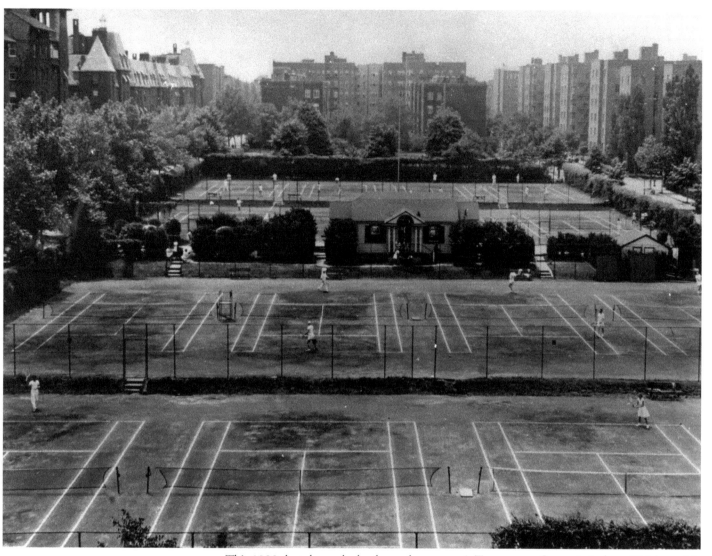

This 1928 shot shows the landscaped grass tennis Tournament Courts in Jackson Heights, with players wearing the traditional all-white outfits for club play—including long skirts for women. The surrounding buildings were not built until 1914, when the Queensboro Corporation transformed the former swampland into cooperatives and apartments, with large inner courtyards. The neighborhood is named for John C. Jackson, and Jackson Avenue (Northern Boulevard) forms its southern border.

The main shopping strip in Jackson Heights has always been 82nd Street. Seen here at Roosevelt Avenue are the English Gables, designed by Robert Tappan specifically for the Queensboro Corporation, which had its headquarters in a large Tudor at the intersection of 82nd and 37th Avenue. Queensboro developed most of the area and was notoriously meticulous about controlling the neighborhood's character. Many of the facades still line 82nd Street today.

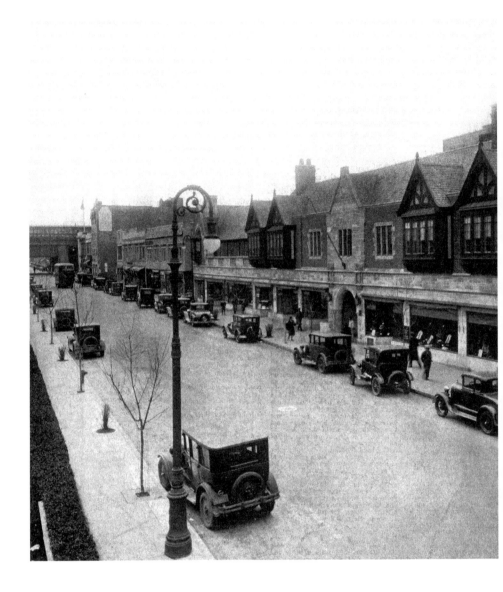

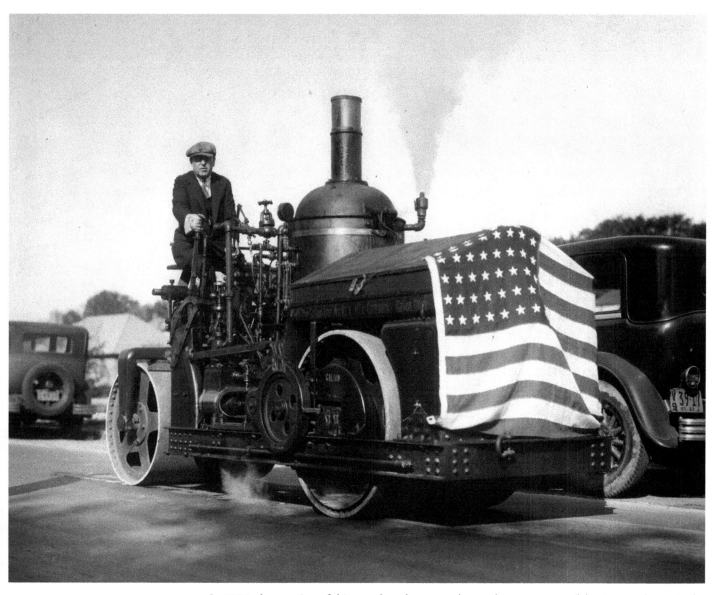

In 1929, the opening of this paved road was grand enough to warrant a celebration, as shown in the photograph. This patriotically decorated machine is a true steamroller (powered by a steam engine, at center)—and operated with Queens class by a Queens public works commissioner named J. J. Halloran, who wears a three-piece suit and a tie.

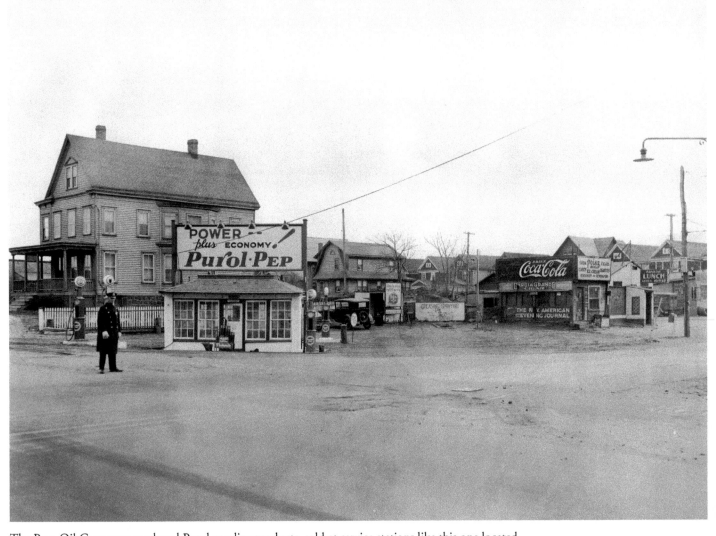

The Pure Oil Company produced Purol gasoline products, sold at service stations like this one located on Woodhaven Boulevard at Queens Boulevard. Purol Pep was gold in color and pumped from blue pumps, while Purol Ethyl was pumped from white pumps. A uniformed policeman, complete with full coat and white gloves, eyes the photographer in the middle of the intersection.

ERA OF THE GREAT DEPRESSION

(1930–1939)

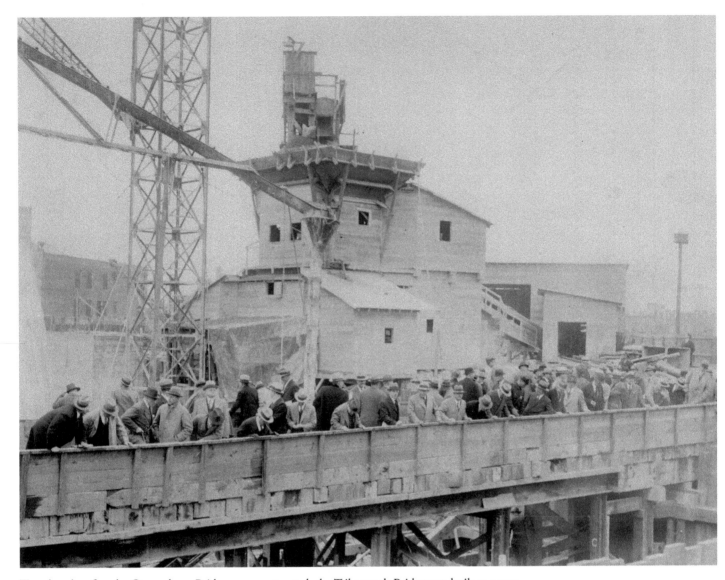

Two decades after the Queensboro Bridge was constructed, the Triborough Bridge was built at a cost of $60 million—one of the costliest public works projects of the Great Depression. The triple-span bridge connects Astoria to Ward's Island–Randall's Island, then forks to a bridge to the South Bronx and a bridge to East Harlem. With construction underway here in 1931, dignitaries are visiting the Queens side of the bridge. In 2008, the bridge was renamed for former New York senator Robert F. Kennedy.

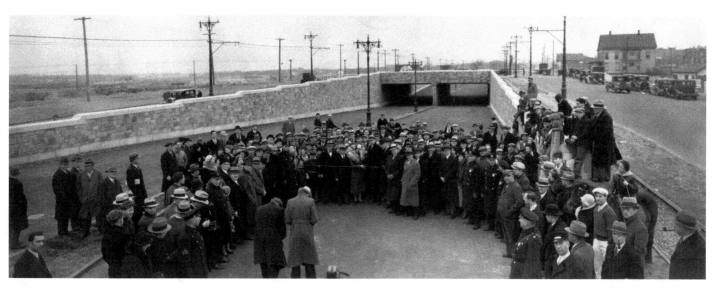

A historic event in 1932, when crowds gathered along with local politicians to mark the opening of the underpass at Queens Boulevard, in Rego Park at Woodhaven Boulevard, near Horace Harding Boulevard—a four-lane road that ran all the way to Shelter Rock Road in Nassau County (reportedly to allow its benefactor easier access to his country club). Within a decade, Horace Harding Boulevard was converted to an "express highway" and eventually transformed into the Long Island Expressway, which now runs from the Midtown Tunnel to the eastern end of Long Island.

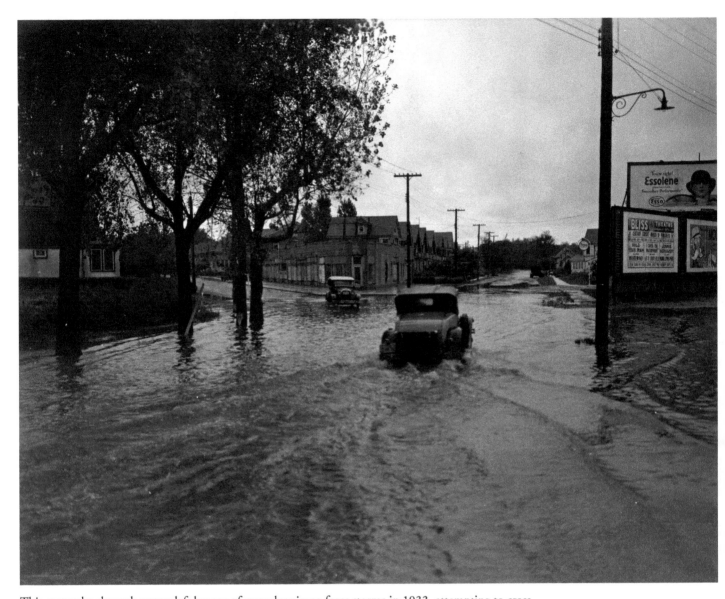

This car wades through waters left by one of many hurricane-force storms in 1933, attempting to cross St. James Avenue on 51st Street near Queens Boulevard in Elmhurst. The hurricane season of 1933 had the most Atlantic Ocean hurricanes on record until 2005, and the city was battered and flooded, despite advances in sewage systems and public works across the city.

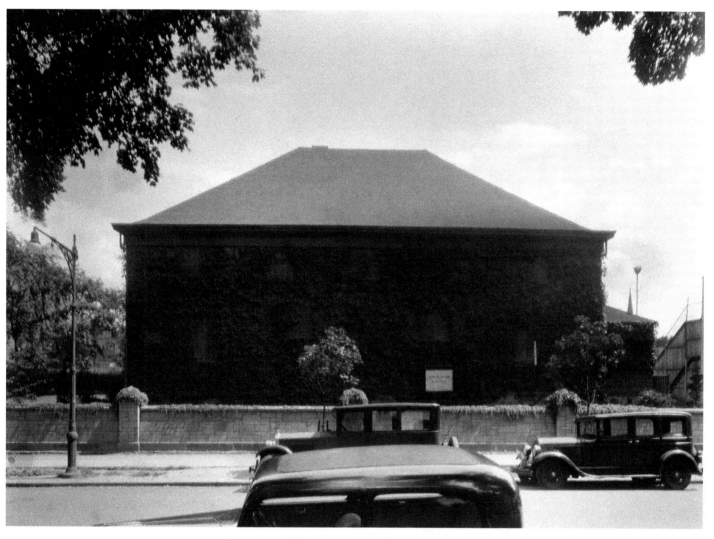

The Society of Friends Meeting House on Northern Boulevard in Flushing was built in 1694 and is the second-oldest Quaker meeting house in continuous use in the United States. It is supposedly modeled on the home of John Bowne, the leader of the Flushing Remonstrance in 1657, who fought for religious freedom with the West India Trading Company and the Director-General of New Netherland, Peter Stuyvesant.

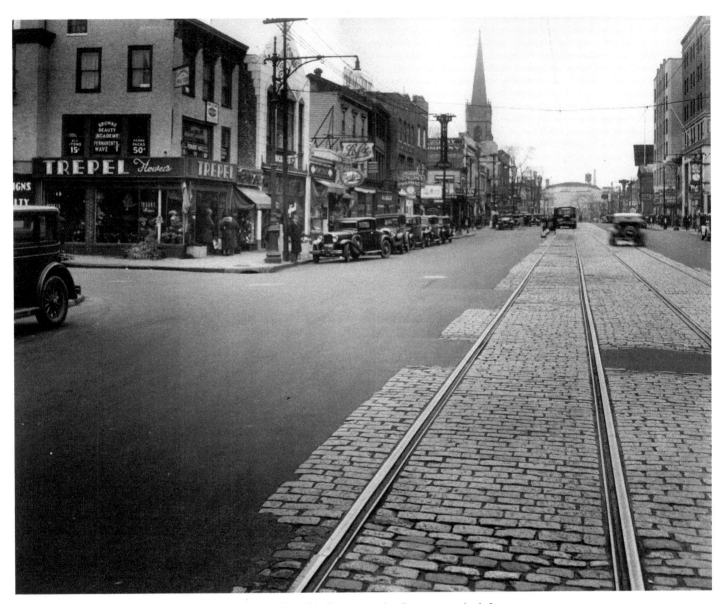

Main Street at 40th Road in Flushing. The large steeple and bell tower in the distance on the left adorns St. George's Episcopal Church which, to date, has served Flushing residents for more than 300 years. In 1854, this Neo-Gothic building replaced the original structure built in 1746.

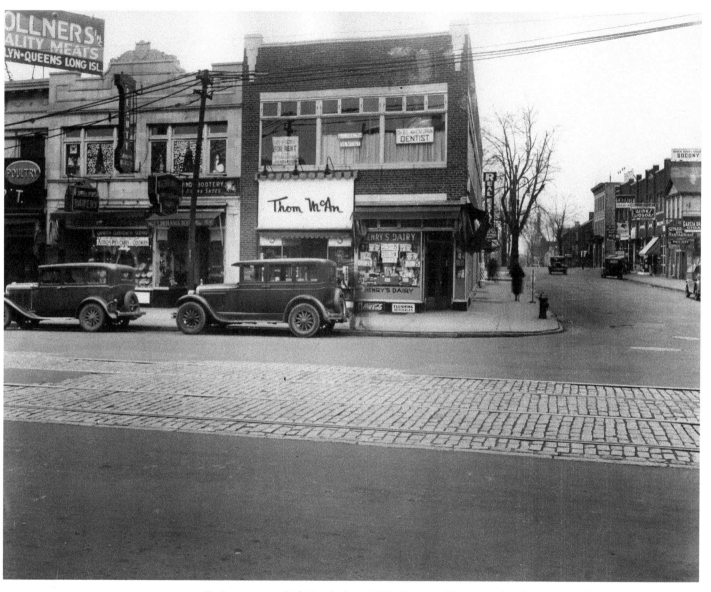

Facing west on 40th Road, from Main Street in Flushing. The Thom McAn shoe store in the center of the frame was one of hundreds of outlets across the nation, run by Ward Melville's Melville Corporation. Melville once had a broad slate of brands under his umbrella, but today the corporation shepherds only one company, CVS Pharmacies.

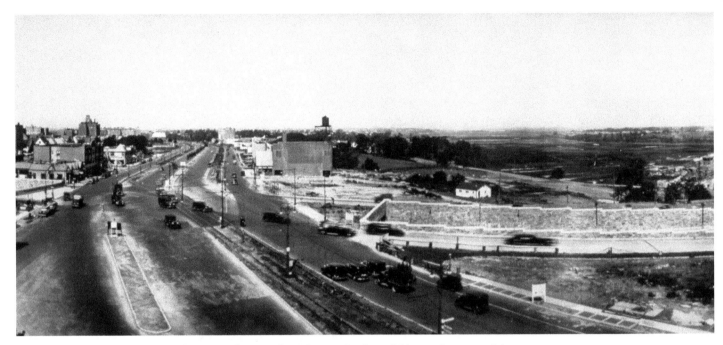

A bird's-eye view of the Kew Gardens Interchange, where Queens Boulevard (the road on top of the underpass, which is visible at right) met the Grand Central Parkway, and Union Turnpike runs along the side, seemingly the service road for the GCP. This 1936 photograph shows the parkway soon after it was completed.

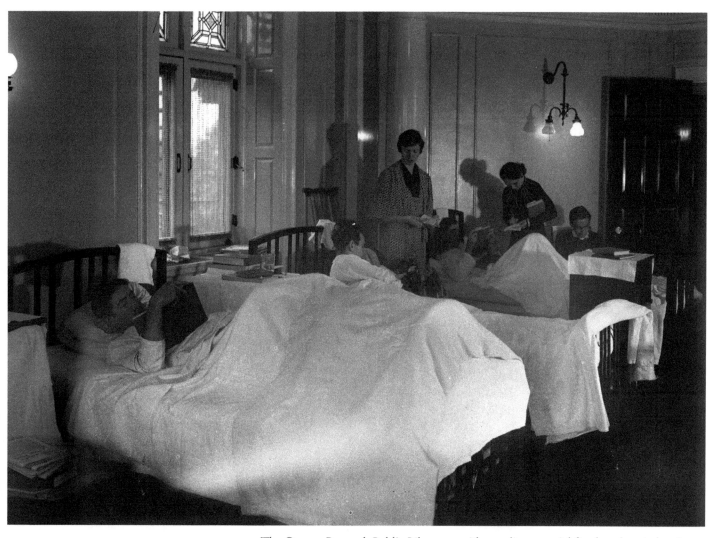

The Queens Borough Public Library provides reading material for these hospital patients, demonstrating that its traveling library served a full range of institutions across the borough.

In 1936, the progression of St. Joachim and Anne Catholic Church and the surrounding area is truly apparent, with sidewalks laid and streets paved. The church still stands on this trapezoidal block on Hollis Avenue near 218th Street in Queens Village.

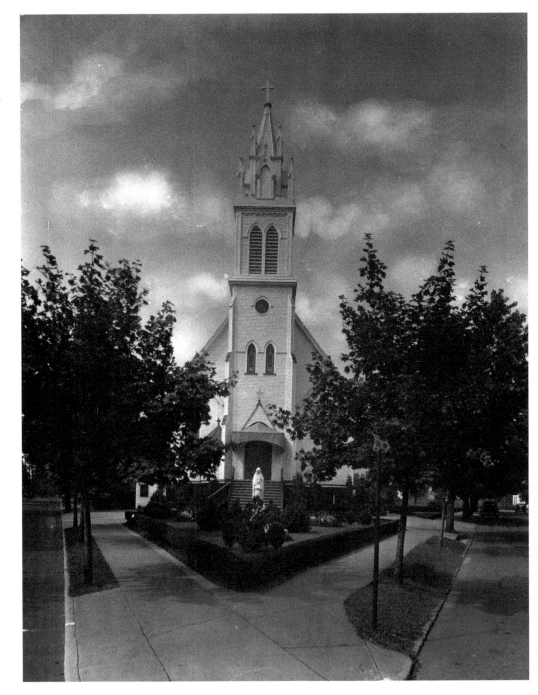

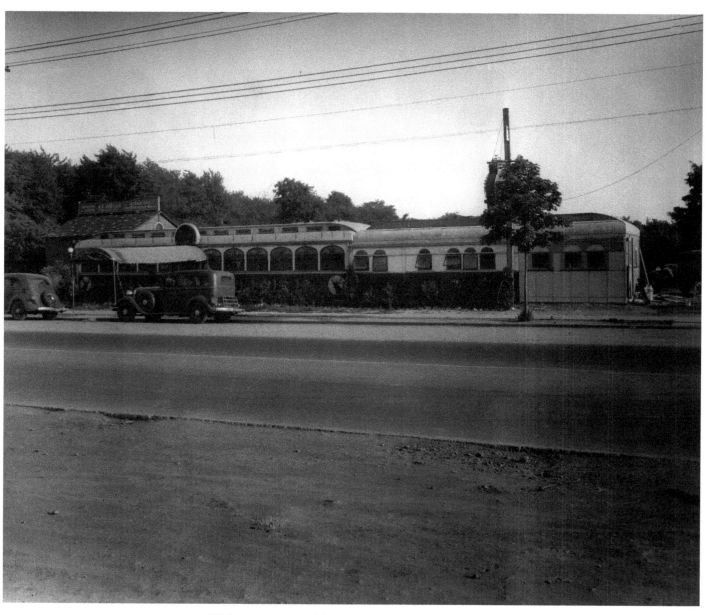

With greater automobile travel came greater opportunities for drivers to patronize roadside eateries like the Deer's Head Diner, one of the classic train dining-car-style diners popular around the nation in the 1930s. This one was located at 235-20 Hillside Avenue, in Bellerose.

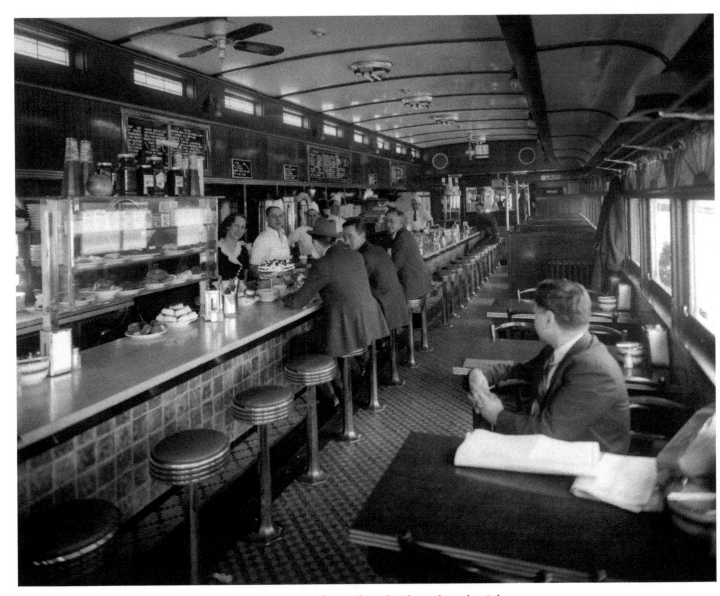

Inside at the Deer's Head diner in 1938, the long counter with round stools, tile work, and stainless steel trim completes the look, a design that still dominates at most diners in New York today.

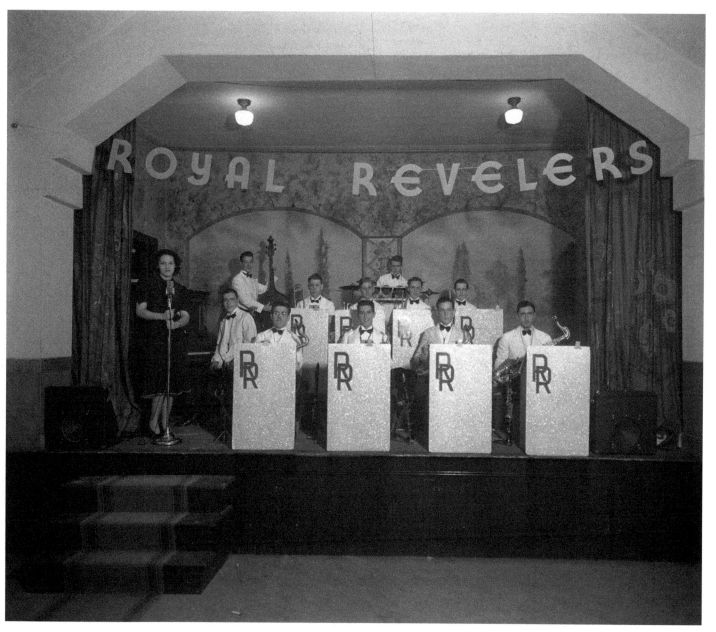

The Royal Revelers band poses during a performance in 1938. Queens was home to many famous names in jazz and big band music, including Count Basie, Ella Fitzgerald, Billie Holiday, Louis Armstrong, Tony Bennett, and Lena Horne, to name just a few.

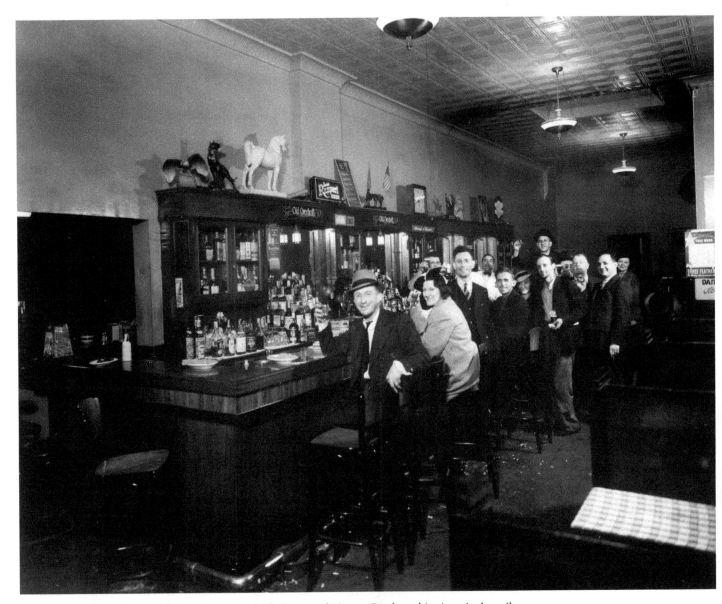

Patrons at V. Caruso's Bar and Grill, located at 35th Street and Vernon Boulevard in Astoria, happily pose for the camera in 1938. The bar would have been located across from Rainey Park, on the edge of the East River, named for Dr. Thomas Rainey who lobbied for a bridge connecting Queens to Manhattan. The Queensboro Bridge was eventually built, about a mile to the south.

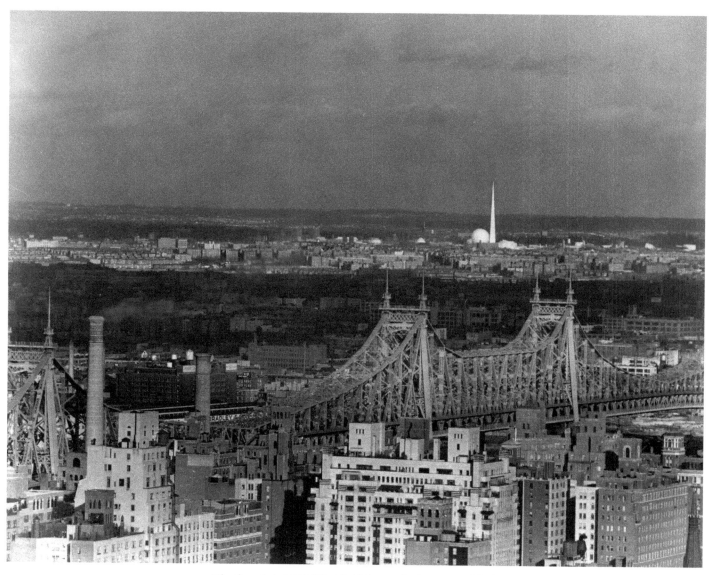

The futuristic 1939 World's Fair was the largest world's fair ever held and covered more than 1,200 acres of former marshland in Flushing. Over 200,000 people were on hand at the opening, when President Franklin D. Roosevelt gave an address. Seen here from Manhattan, with the Queensboro Bridge in the middle foreground, the Trylon spire and Perisphere in what is now Flushing Meadows–Corona Park gleam white in the distance.

Shops along Northern Boulevard, in Flushing, looking toward the corner of Parsons Boulevard. A large section of the shopping center to the left still exists, juxtaposed against newer chain stores and restaurants.

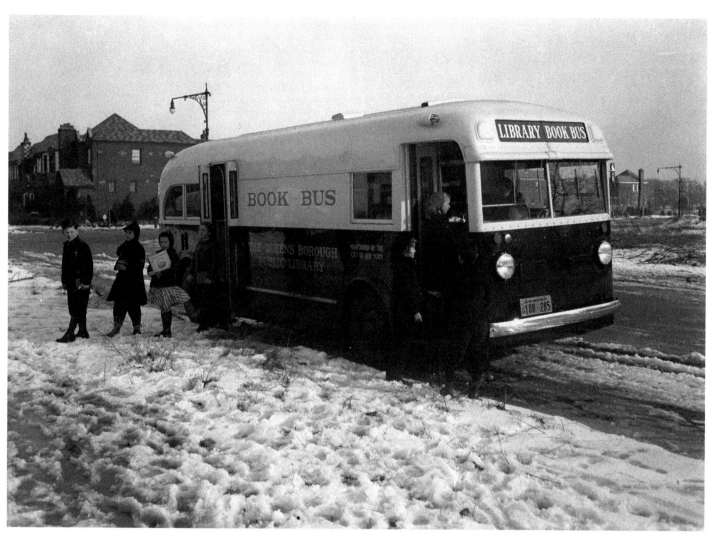

The ever-popular Queens Borough Public Library changed with the times to include this Book Bus, seen here in operation on a snowy day in 1939. The bus is shown serving patrons in Flushing's Queensboro Hill neighborhood.

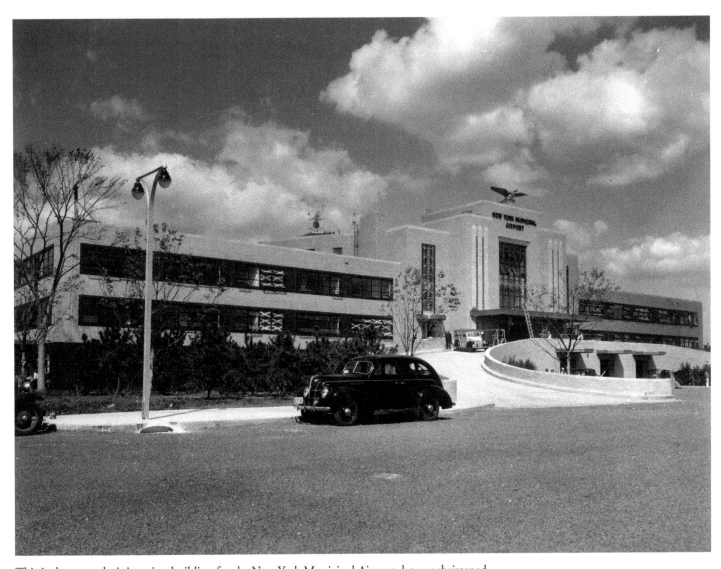

This is the new administration building for the New York Municipal Airport, later rechristened LaGuardia International Airport after Mayor Fiorello LaGuardia, who had pushed for an airport closer to New York City. The airport had previously been known as the small Glenn H. Curtiss airport for private planes and was called the North Beach airport—since it was built on the site of the Steinway family's North Beach amusement park.

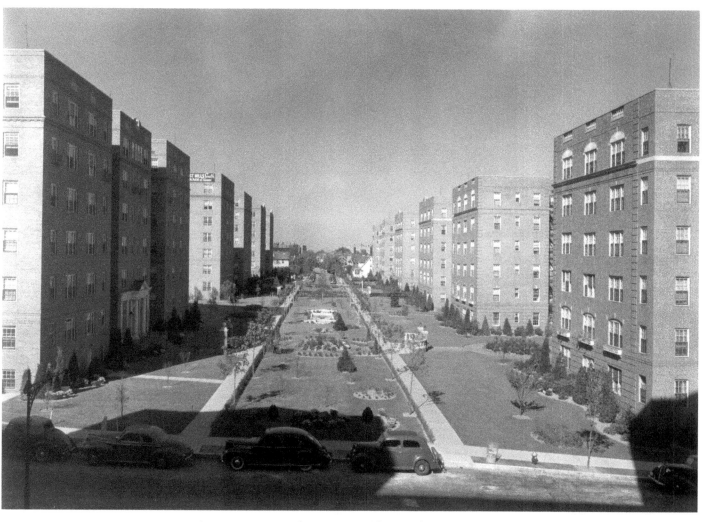

An apartment complex in Forest Hills in 1941. With an abundance of land available on Long Island, industry found expansion room in the borough. Americans seeking jobs followed, bringing their families with them to live in neighborhoods like this one.

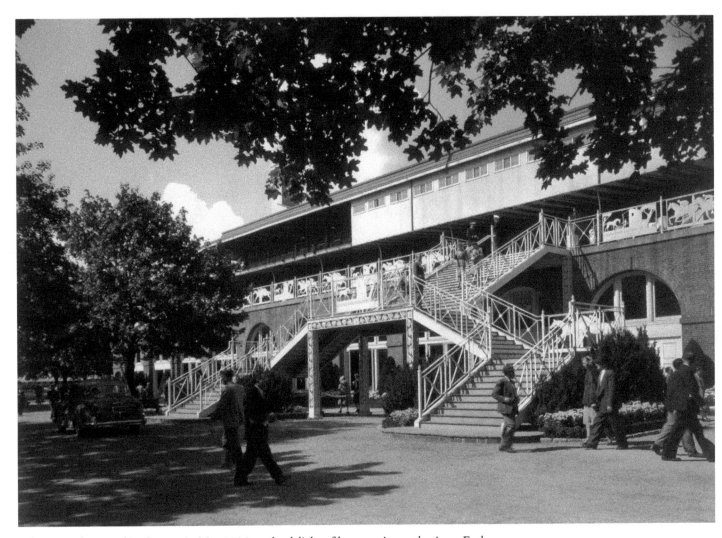

Belmont Park opened in Queens in May 1905, to the delight of horse-racing enthusiasts. Each year, the track hosts the third leg of the Triple Crown of thoroughbred racing. Nearly every champion racehorse has run the one-and-a-half-mile track, among them Secretariat, who set the Belmont Stakes record of two minutes, twenty-four seconds in 1973.

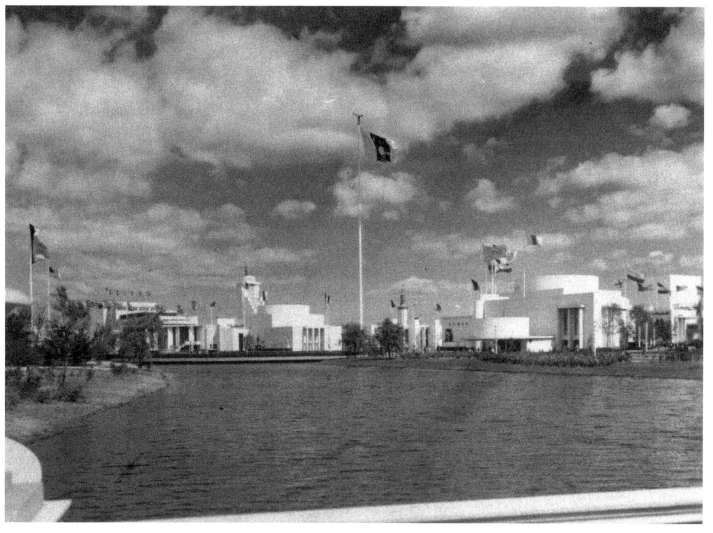

The Government and Nations Zone at the 1939 World's Fair, as seen from the Flushing River, with flags flying in the unusual winds that have plagued aircraft over the decades. More than 60 nations represented their cultures at the World's Fair, which ran for two seasons, until 1940.

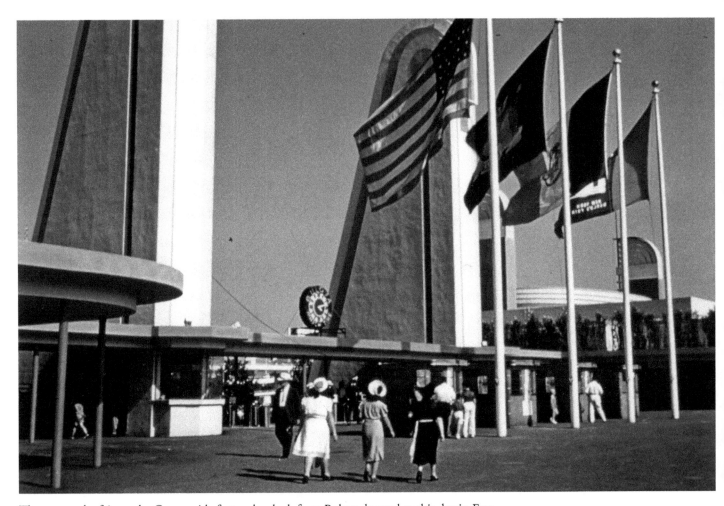

The gate to the fair on the Corona side featured a clock from Bulova, located to this day in East Elmhurst, near the Marine Air Terminal at LaGuardia Airport.

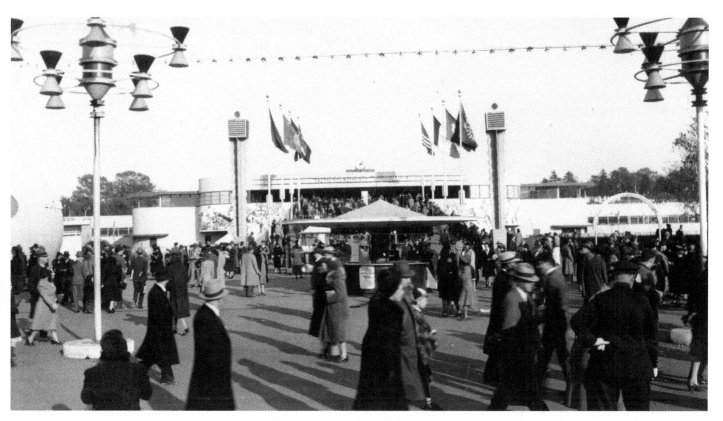

The World's Fair was served by all three subway companies in New York. In the background is the World's Fair Station (now Mets-Willets Point), which had Brooklyn-Manhattan Transit and IRT train service. There was also service from the World's Fair Railroad station, an extension of the Queens Boulevard Independent Subway Line.

A tournament at the Jackson Heights Golf Club—a place made even more unusual because it was acres of land surrounded by the large apartment buildings the neighborhood was known for. After World War II, the golf course was paved over to make way for a new influx of residents.

THE WORLD WAR II AND POSTWAR WORLD

(1940–1970s)

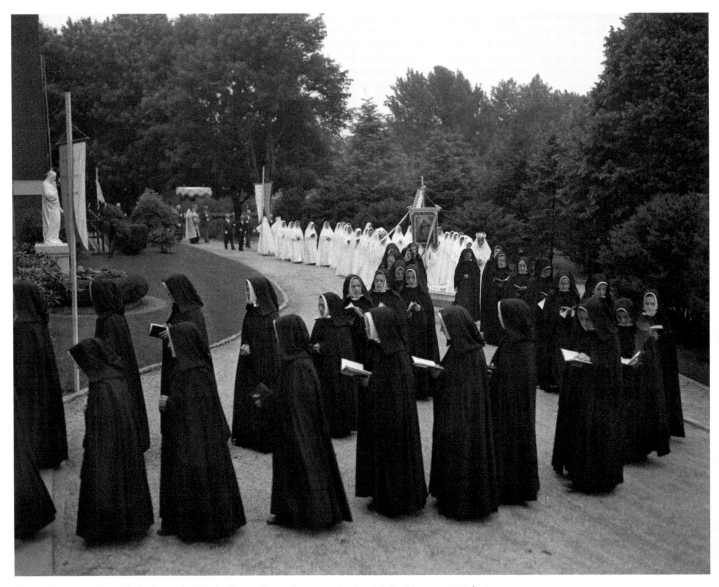

Sisters in procession, likely from the Little Sisters-Poor Convent, St. Ann's Novitiate, at 110th Avenue and Springfield Boulevard in Queens Village.

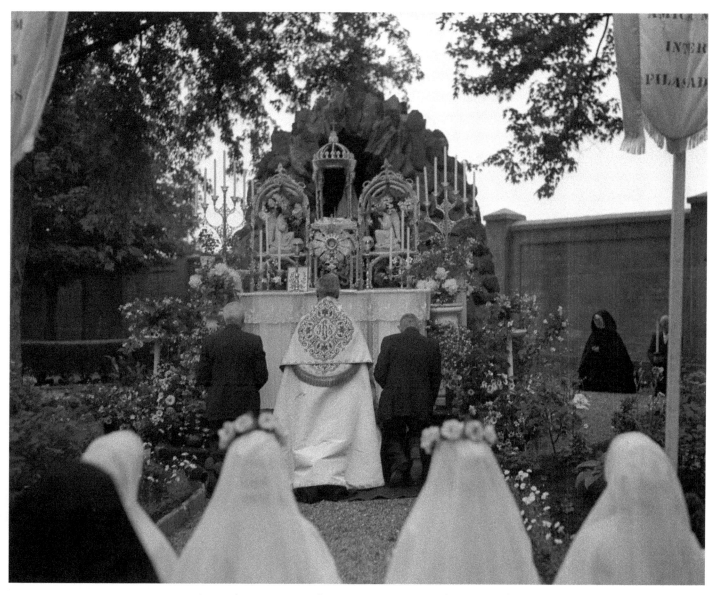

An outdoor mass at an altar set up in a grotto, with priests in the center of the frame, and sisters in the foreground.

One of the garden courtyards at the Phipps Garden Apartments on 39th Avenue in Sunnyside. The development was started in 1905 with a $1 million investment by philanthropist Henry Phipps, a partner in Andrew Carnegie's steel business, and has consistently provided affordable housing to low-income and moderate-income families from that day forward.

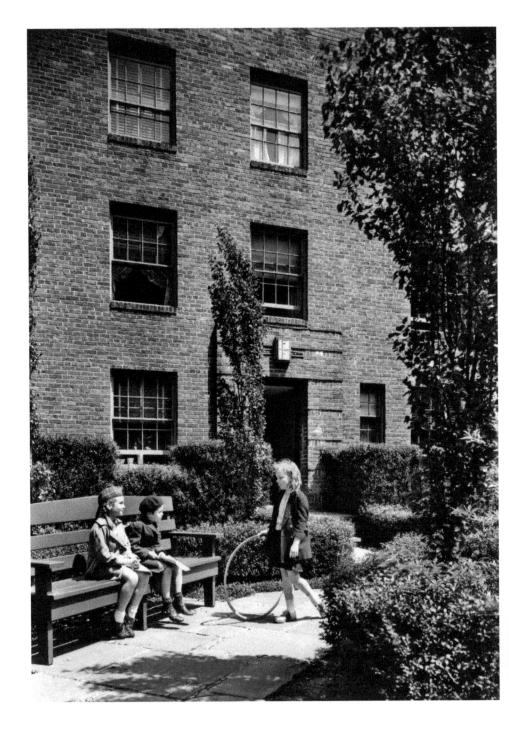

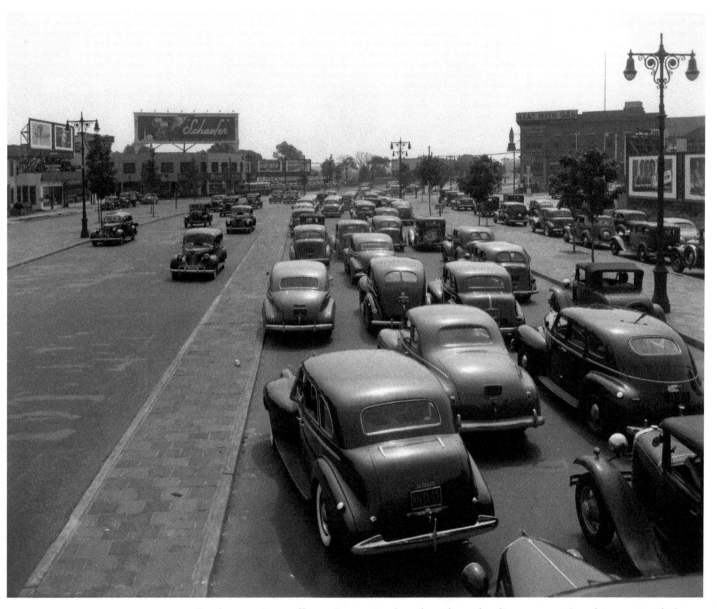

Sunday morning traffic on Queens Boulevard was heavy heading east past Grand Avenue in Elmhurst. The large Schaefer Beer ad on the billboard at upper-left advertises the brew that was one of the top beers in the world at mid-century.

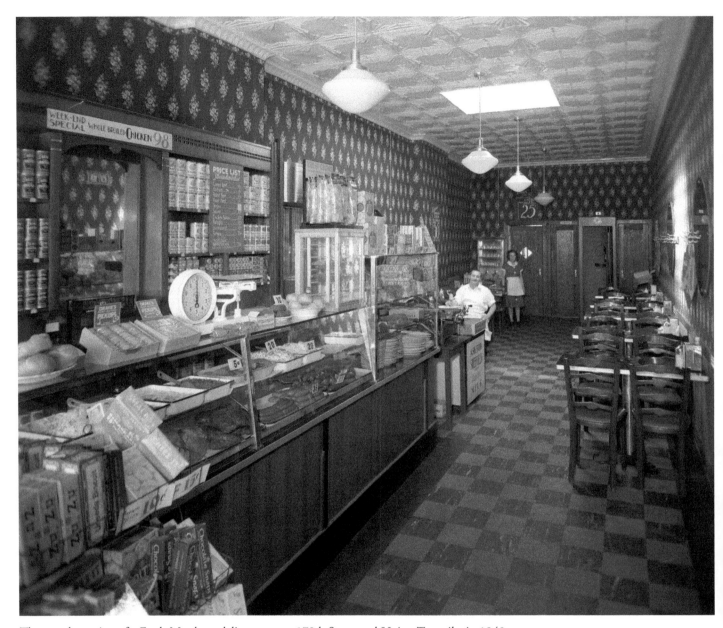

The grand opening of a Fresh Meadows delicatessen on 178th Street and Union Turnpike in 1940.

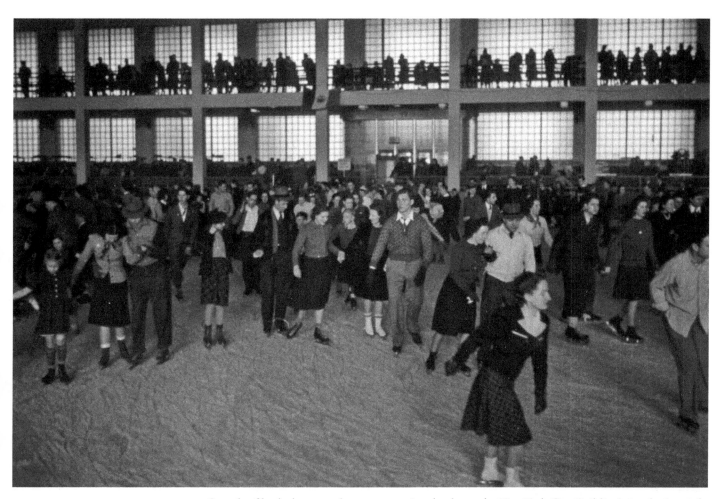

Crowds of both skaters and spectators enjoy the day at the New York City Building's ice-skating rink, the first such facility in New York City. The massive rink was built for shows and spectator use at the 1939 World's Fair and was later used as the temporary home of the United Nations, until the U.N. building in Manhattan was completed in 1952. It regained fame during the "Ice-Travaganza" shows during the 1964–65 World's Fair. With the departure of ambassadors and fairs, skaters returned and the rink was used year-round until 2008.

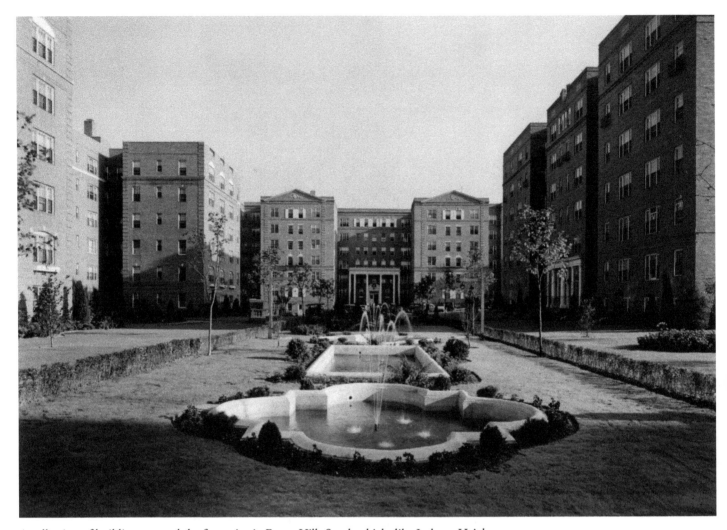

A collection of buildings around the fountains in Forest Hills South which, like Jackson Heights, exhibits significant influences from the British "Garden City" movement. The area has many beautiful styles of buildings, with attention clearly paid to form as well as function, as seen here in 1941.

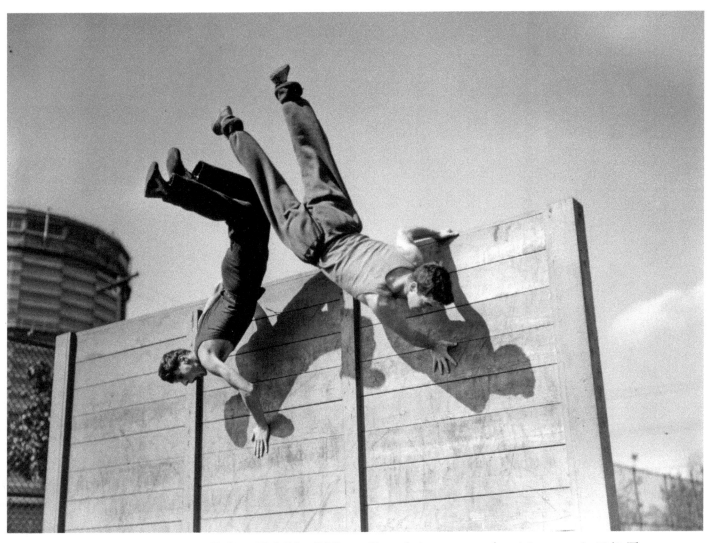

Flushing High School's Victory Corps during a commando training course in 1942. The course was offered by the physical education department and featured basic training drills, such as the wall scaling seen here, intended to keep the boys in top shape in case they were called to serve in World War II.

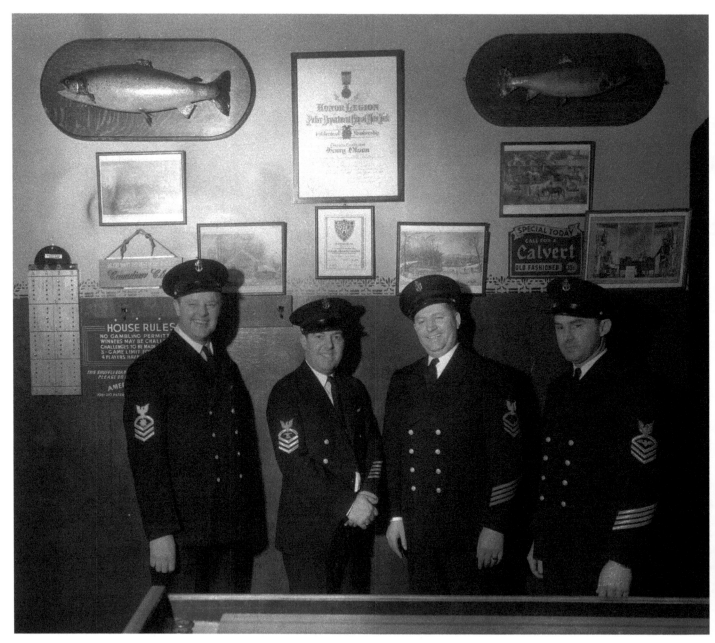

With the Japanese attack on Pearl Harbor in December the year before, the nation was now at war. This group of off-duty officers pose in full Navy blues for a bit of shuffleboard at a tavern in 1942.

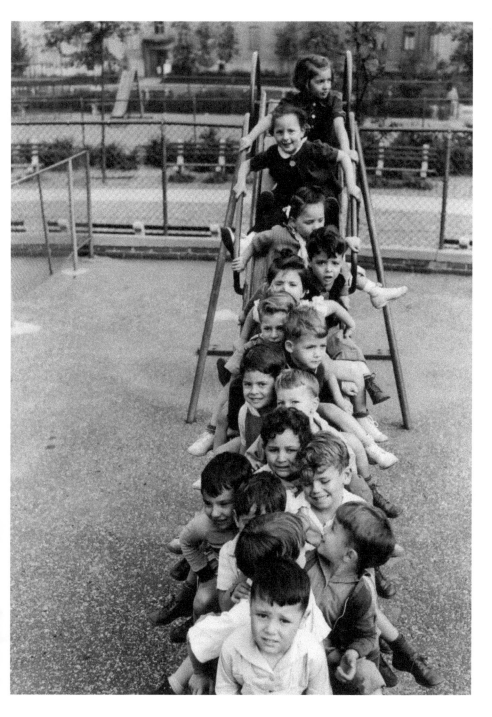

More than a dozen children at the Queensbridge Housing Project are perhaps trying to set a record on this slide at the playground on the grounds of the complex, which is directly adjacent the Queensboro Bridge landing in Long Island City. The project is the largest in the nation, with nearly 7,000 residents in more than 3,100 units, built in a nontraditional "Y" shape, which was thought to be more economical. The buildings were completed in 1939.

Mrs. Joliet Jones works as a toll collector at the Queens-Midtown Tunnel, apparently hired to replace a man who joined the armed forces to defend the nation in World War II. Mrs. Jones is seen here on her first day as a collector on special duty.

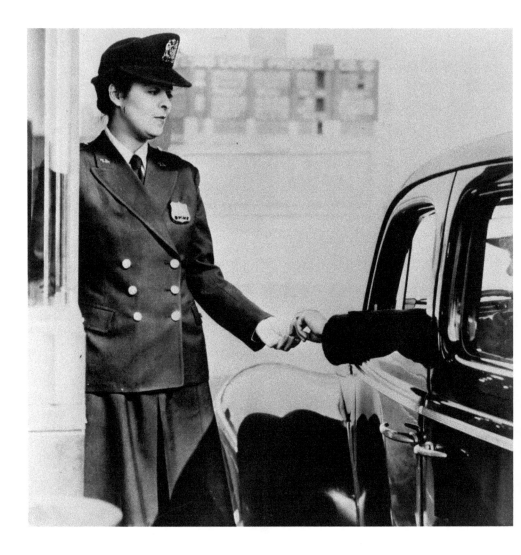

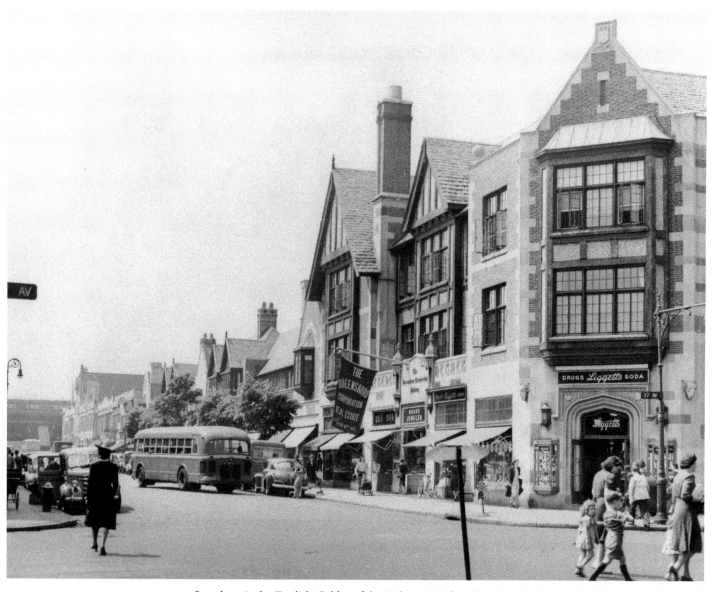

Seen here is the English Gables of the Jackson Heights shopping district on 82nd Street near Roosevelt Avenue, where the IRT elevated subway station is visible in the left distance. The building on the corner was Liggett's drugstore, with the offices of the Queensboro Corporation to the left.

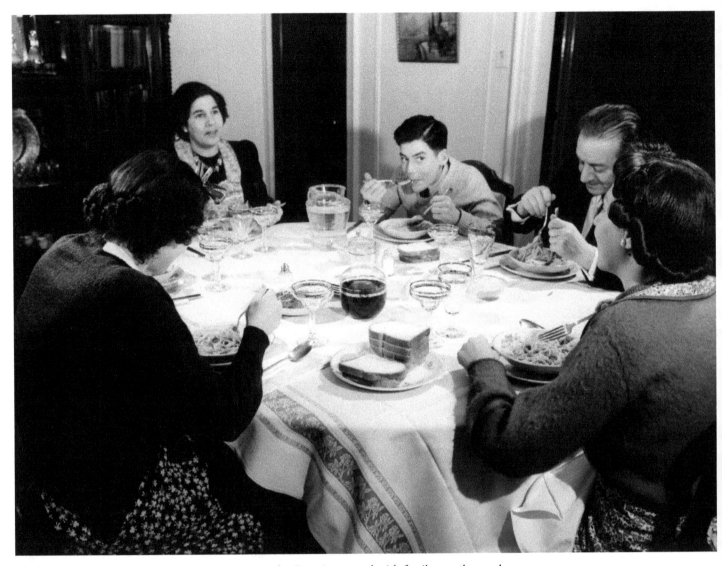

An intimate portrait of life in Corona in January 1942. Enjoying a meal with family members at home in the dining room are Raymond Fazio, a garment worker, and his wife, also in the garment business.

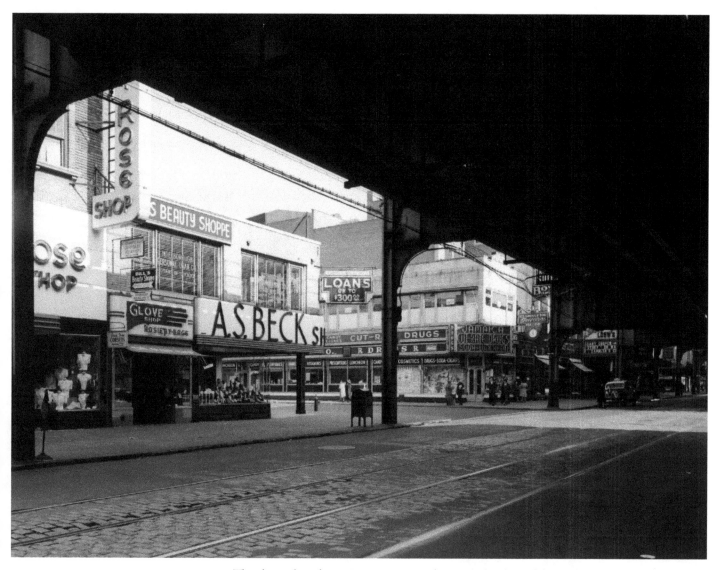

The elevated tracks on Jamaica Avenue dominate the sky and frame the largest shopping area in Queens during the war era, with retail establishments large and small stretching for miles. Parts of Jamaica Avenue still have elevated tracks today, although the area in Jamaica now has underground tunnels. Jamaica was also the main hub of the Long Island Railroad in Queens, where transfers to nearly every line took place at the station on Sutphin Boulevard—which now gives access to John F. Kennedy Airport.

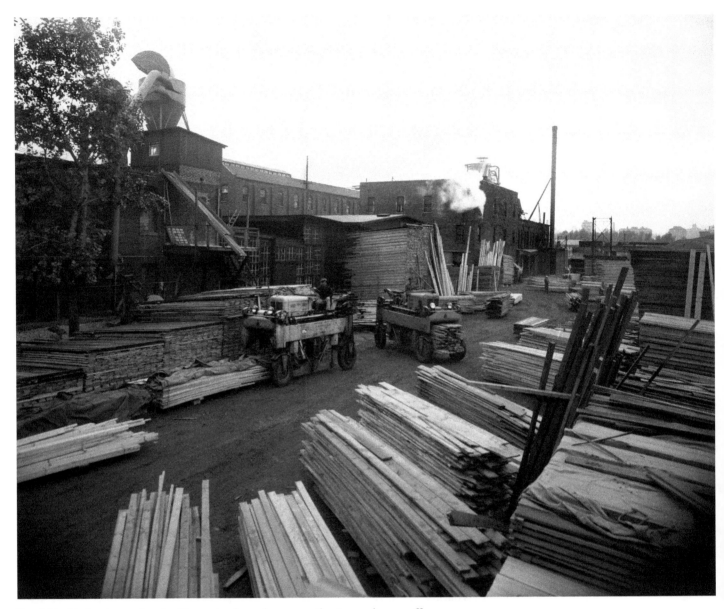

In 1945, this lumberyard and mill remained very busy contributing to the war effort.

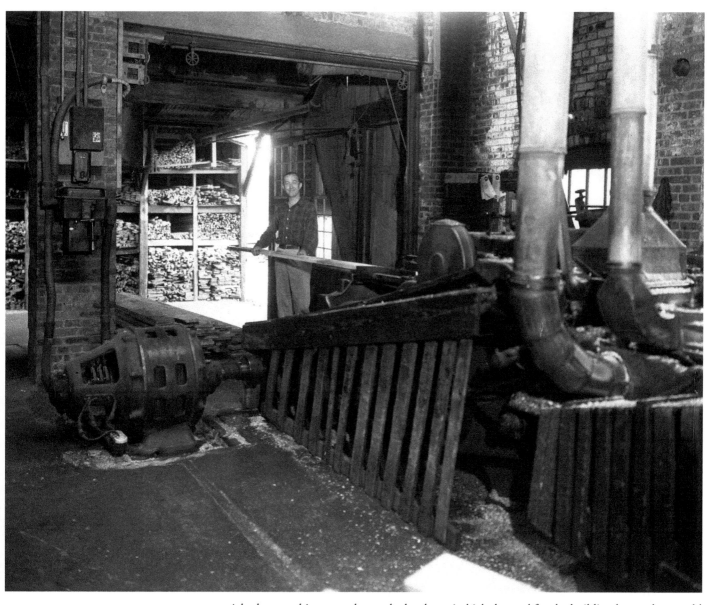

A look at machinery used to make lumber—in high demand for the building boom that would follow the end of the war, although much of that building would be for homes in Nassau and Suffolk counties, as Queens faced its share of departures for points east.

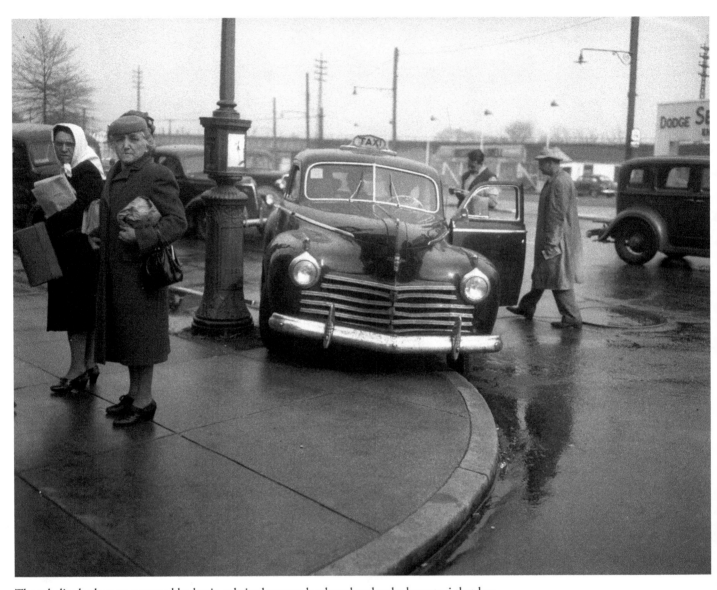

These ladies look more annoyed by having their photograph taken than by the large taxi that has jumped the curb at 212th and Jamaica Avenues in Hollis, in a 1947 accident.

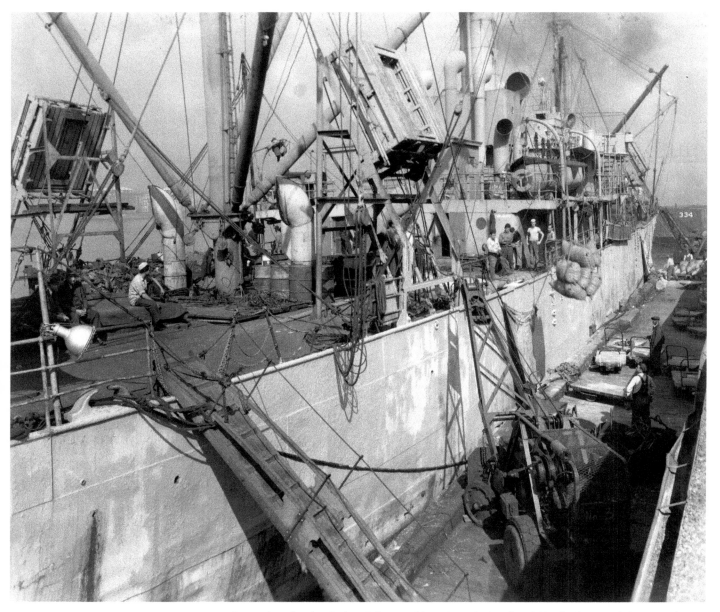

Not to be outdone by the docks of the Brooklyn Navy Yard and Red Hook, Queens did its part during the war. Seen here, a cargo ship is being unloaded at the East River dock at a Queens manufacturing plant a few years after the war ended.

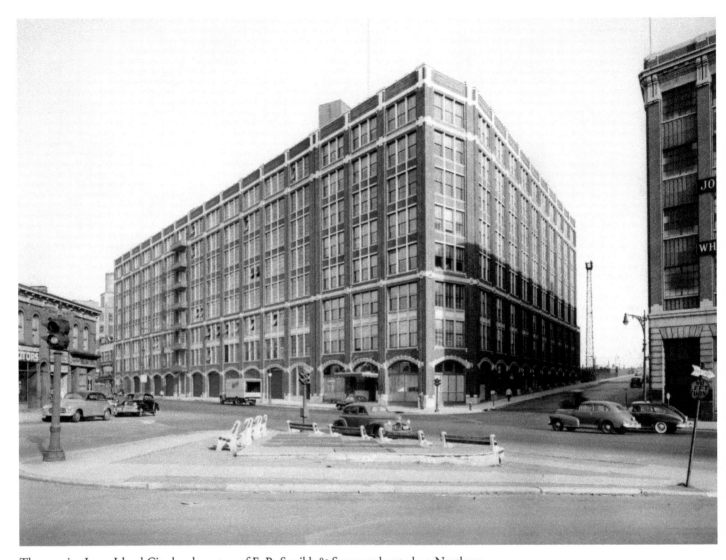

The massive Long Island City headquarters of E. R. Squibb & Sons was located on Northern Boulevard. Squibb later joined with another New York–based pharmaceutical giant, Bristol-Myers, in a larger merger. E. R. Squibb died in 1900, but his sons, Dr. Edward H. Squibb and Charles F. Squibb, carried on the family business.

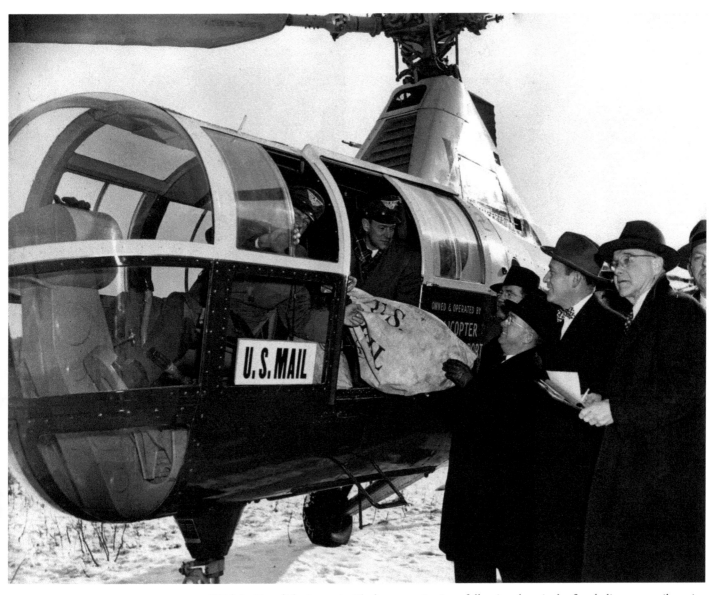

With LaGuardia's airport in Elmhurst getting into full swing, here is the first helicopter mail service flight by the United States Postal Service, an experiment with the new technology. Pictured (left to right) are Pierce H. Power, the Queens Chamber of Commerce vice-president, along with Long Island City postmaster Moses Symington, borough president James Lundy, and Francis X. Hussey, Superintendent of the Mails.

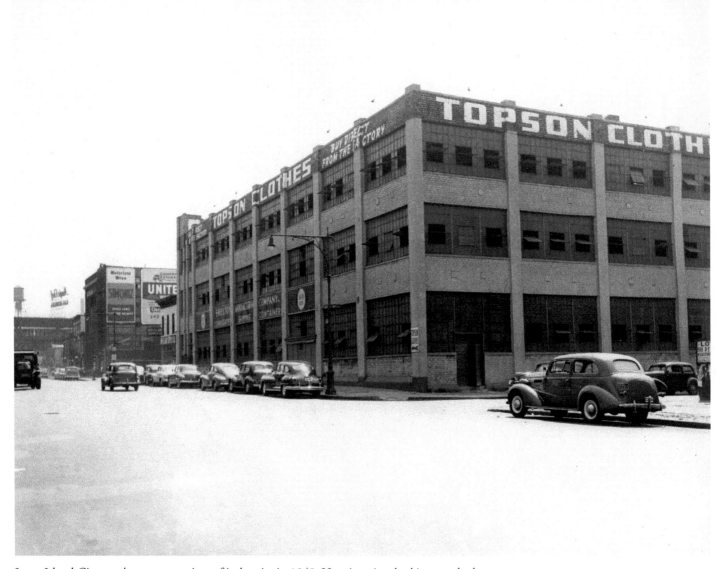

Long Island City was home to a variety of industries in 1948. Here is a view looking north along Jackson Avenue at some of the businesses, including the Topson clothing factory which, as the sign advertises, also did some of its own discount retailing.

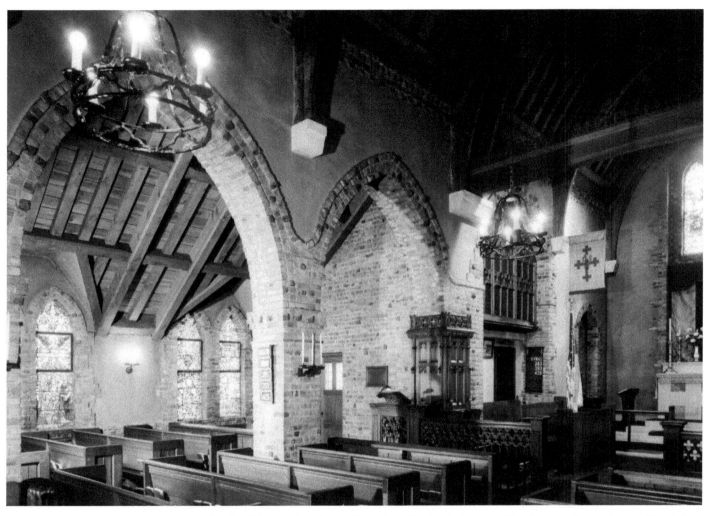

The English Gothic arches of St. Luke's Church, in Forest Hills. The church was designed by Robert Tappan, an architect who was a member of the Episcopal congregation. Tappan was overseeing construction of the Cathedral of St. John the Divine in Manhattan (one of the city's greatest houses of worship) by day and devoted his spare time to this smaller project, which features soaring ceilings and a shape much like an upturned ship from the inside, with high stained-glass windows allowing ample light to fill the nave.

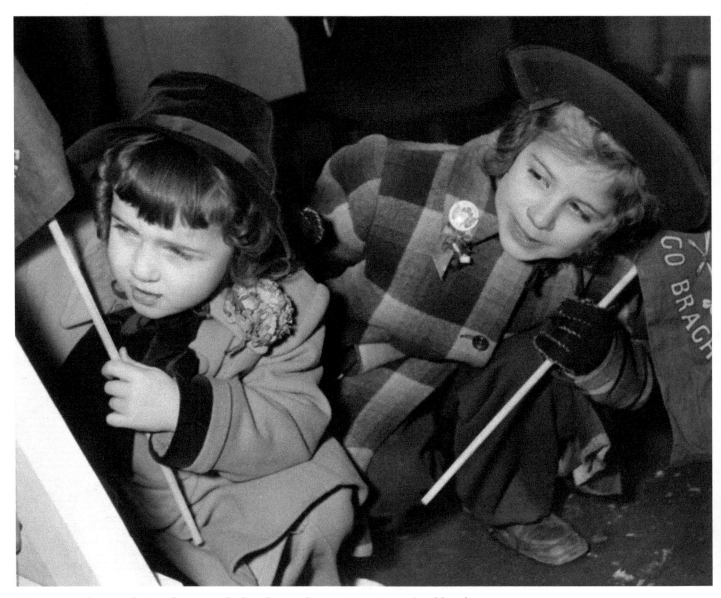

Two young girls crane their necks to get a look at the marchers participating in the oldest, largest, and greatest St. Patrick's Day parade in the world. Queens has always had a large concentration of Americans of Irish descent—from Woodside to Bayside to the Rockaways—and the annual event not only includes many Irish-American marchers from schools, the NYPD, FDNY, and other organizations, but also draws large crowds from the borough.

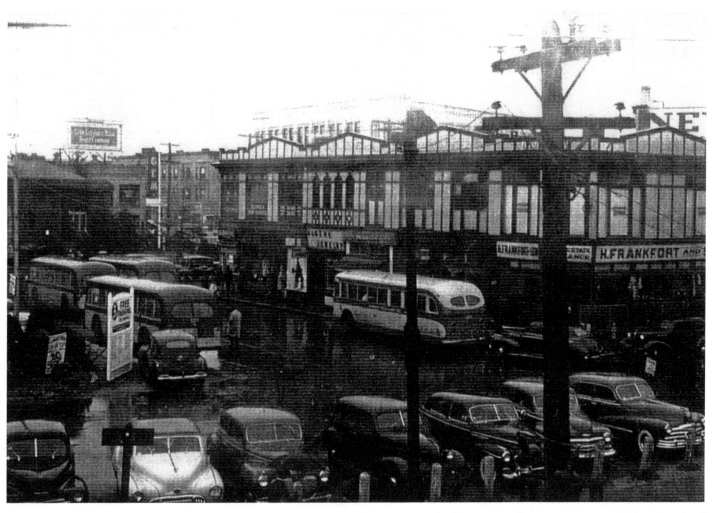

In Queens, as across the nation, city leaders came to view streetcars as an outdated mode of transportation, replacing them with buses in the 1930s and 1940s. Buses ferried railroad commuters to and from stations, as parking was not always available. Seen here in 1953 is the Far Rockaway Bus Terminal located outside the railroad station that keeps the isolated community connected to the rest of the city.

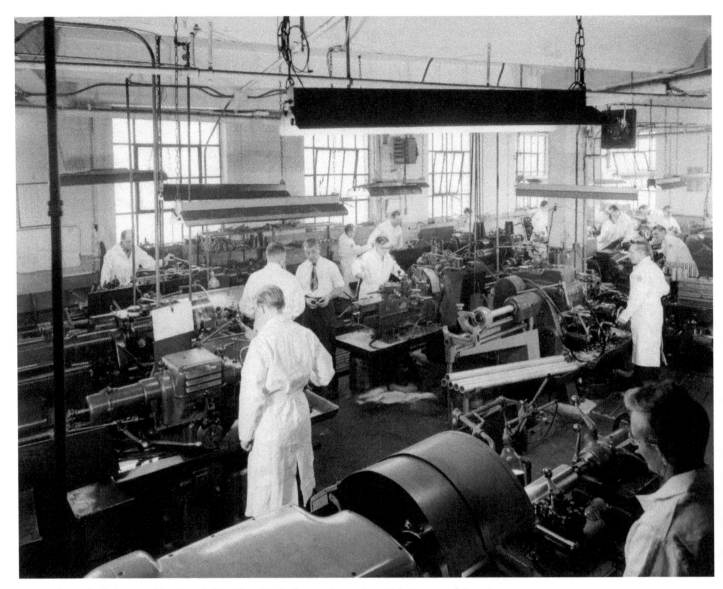

A view from the balcony of the F & R Machine Works factory located at 44th Street and Astoria Boulevard, in full swing in 1953.

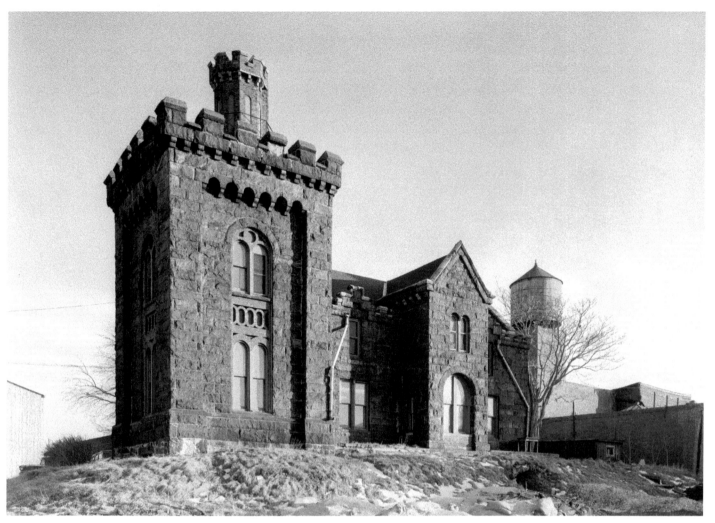

Seen here in 1960, a few years before its demolition, Bodine Castle was long a Ravenswood landmark.

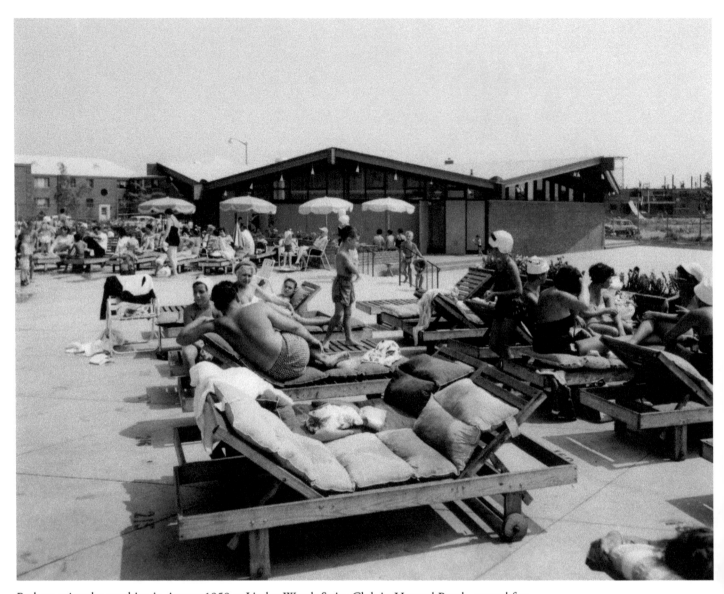

Bathers enjoy the sunshine in August 1959 at Linden Woods Swim Club in Howard Beach, named for
the vast woodlands that once covered the peninsula, just north of Rockaway, before it was developed.
Clearly, attitudes toward swimwear had relaxed significantly by the middle of the century, as seen by
the bathing suits worn by club members.

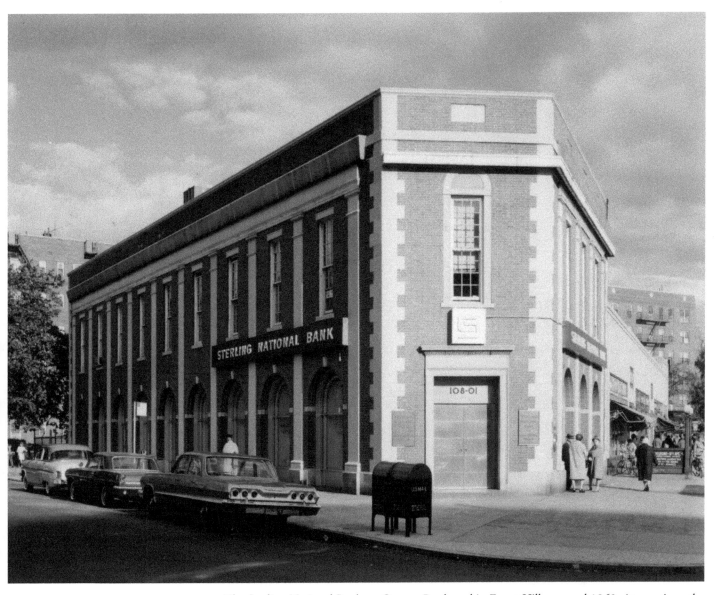

The Sterling National Bank on Queens Boulevard in Forest Hills, around 1963. At one time, the building was used as a Masonic Temple. This unusual bank is still operating near the center of Forest Hills, just steps from the 71st–Continental Avenue subway station, which is just to the right of the bank.

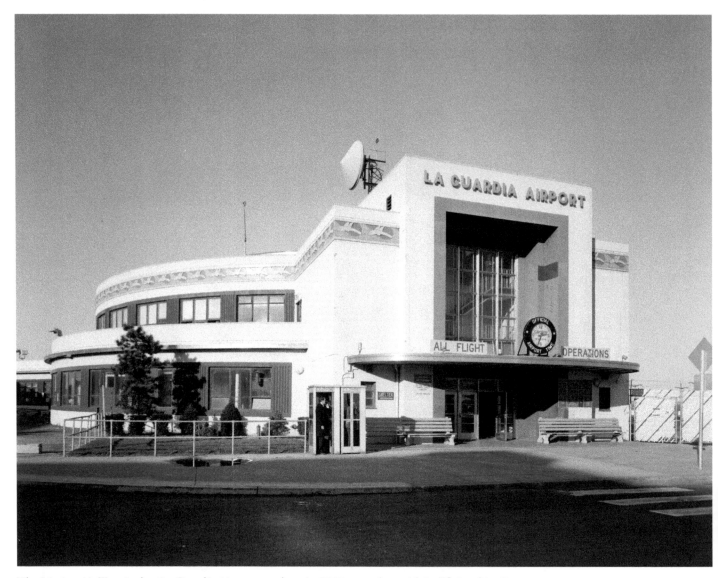

The Marine Air Terminal at La Guardia Airport seen here in 1968, complete with its "flying frieze" around the top, was built as part of a WPA project and is a shining example of Art Deco architecture. In addition to the frieze is a mural on the round ceiling of the waiting room titled *Flight,* which was created under the Federal Arts Project, a federal program that funneled tax dollars into jobs for artists during the Great Depression. The terminal was built on the bay for seaplanes that made transatlantic flights. It remains in use today.

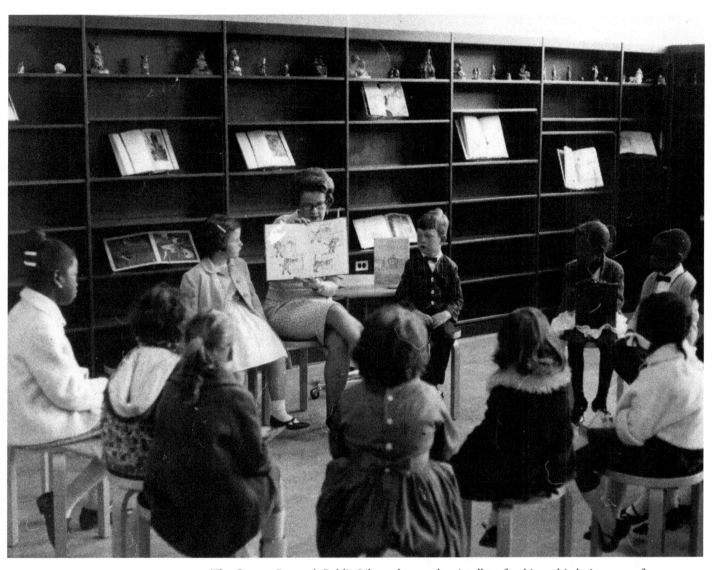

The Queens Borough Public Library has not lost its allure for this multiethnic group of youngsters, gathered for story time at a library branch in the 1960s. At a time when issues of segregation rocked the nation, there seems to be no problem in this story room beyond getting a closer look at the pictures.

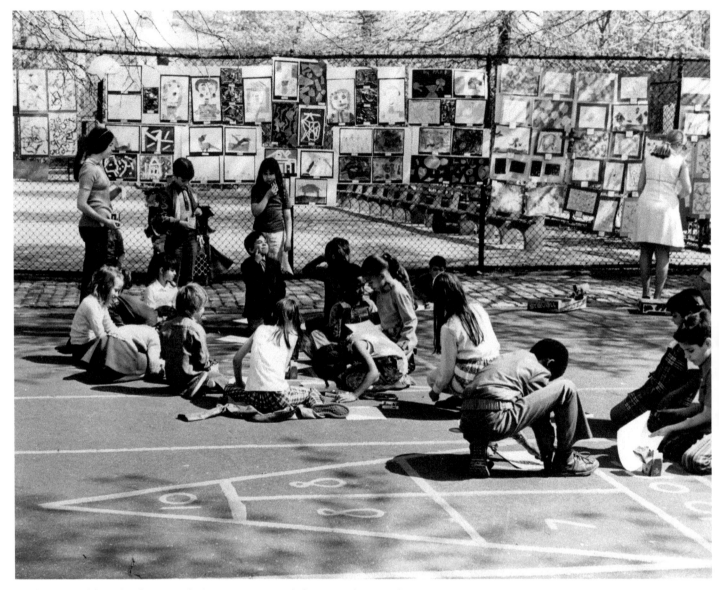

Students at Public School 201 in Flushing create artwork for an outdoor art show in May 1971.

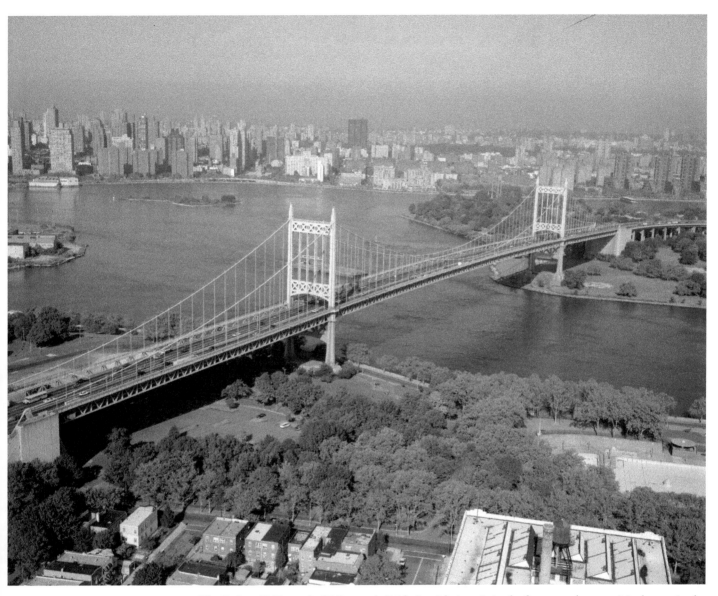

The Robert F. Kennedy (Triborough Bridge), with Astoria in the foreground, upper Manhattan in the background, and Randall's Island in the center, around 1968. Randall's Island has multiple ball fields and today is a popular site for large outdoor concerts.

Notes on the Photographs

These notes, listed by page number, attempt to include all aspects known of the photographs. Each of the photographs is identified by the page number, a title or description, photographer and collection, archive, and call or box number when applicable. Although every attempt was made to collect all data, in some cases complete data may have been unavailable due to the age and condition of some of the photographs and records.